GLOUCESTER COUNTY COLLEGE LIBRARY

3 2927 00050 6085

TS
250
S42 GLOUCESTER COUNTY COLLEGE
LIBRARY
SEWELL, NEW JERSEY 08080

80-00770

DATE DUE

GLOUCESTER COUNTY COLLEGE
LIBRARY
SEWELL, NEW JERSEY 08080

WITHDRAWN FROM
RCSJ LIBRARY

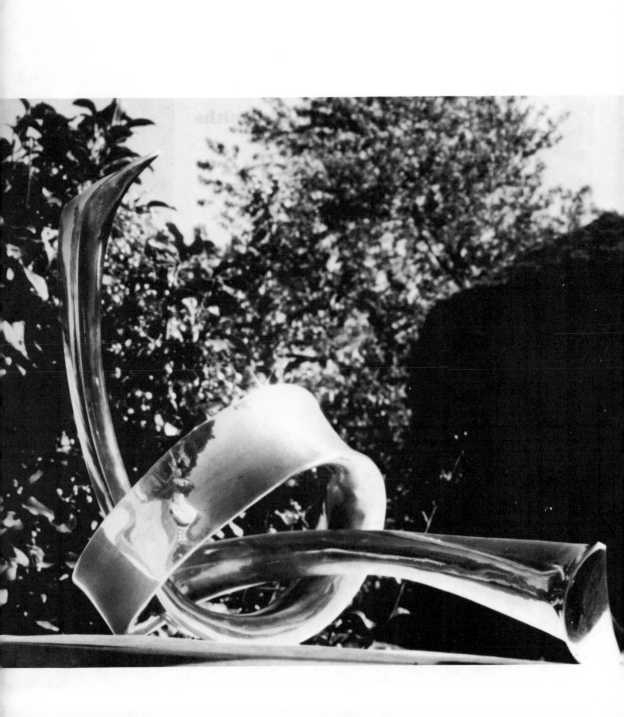

FORM
EMPHASIS
FOR
METALSMITHS

Heikki Seppä

The Kent State University Press

Copyright © 1978 by The Kent State University Press
All rights reserved
Manufactured in the United States of America

Designed by Harold Stevens

ISBN: 0-87338-212-9
Library of Congress Catalog Card Number: 78-1091

Library of Congress Cataloging in Publication Data
Seppä, Heikki.
 Form emphasis for metalsmiths.

 1. Sheet-metal work. 2. Art metal-work.
I. Title.
TS250.S42 739 78-1091
ISBN 0-87338-212-9 pbk.

Young ideas are the most fragile of all things. If there is no room for the roots, if there is no acceptance, they will die. This book is dedicated to those who recognize an idea in spite of the embryonic presentation of it.

CONTENTS

Preface

Artists, in seeking to express their ideas, must employ a medium, be it as lasting as marble or as ephemeral as a whisper. A superficial knowledge of the medium limits the possibilities of expression, and leads to atrophy of the creative impulse, whereas the discovery of new modes of expression is the continuing task of all artists.

In metalsmithing, limitation of creativity can occur when artists neglect the basic characteristics of a metal. A thorough knowledge of materials and techniques is a direct measure of artistic freedom; the fewer technical problems that artists must solve, the more spontaneous their art will be. This is especially important for those working in a relatively time-consuming medium like metal — the less time spent between conception and execution, the fresher the idea in the mind of its creator.

These thoughts occurred to me at the Washington University School of Fine Arts in 1973, when it became increasingly apparent that plastics and nonmetals were playing more significant roles as media of expression for metalsmiths in North America. At that time, the underlying forms that were made of metal were quite underdeveloped, sheet metal being used as if it were plywood, cardboard, or a pane of glass, the plasticity of the metal being altogether neglected.

Another hindrance to freedom of artistic expression lay in the product-oriented vocabulary. I felt that a more scientific nomenclature was needed to free artists from thinking of their work solely in terms of its end-product. Coupled with this idea was an increased consciousness of form and a searching examination of both old and new techniques.

A host of terms had to be unearthed or minted afresh to teach and discuss developments properly. For example, *anticlastic* and *synclastic* sinking had never been suggested in the classrooms or in the professional books since neither these terms, nor satisfactory substitutes, were in common use. As a consequence, no developments had taken place in this area. The forms themselves were taken for granted until the suggestion for their analysis in generic terms was adopted. Until then, analysis had been done strictly in terms that referred to already existing objects, with the consequence that "Everything looked like something else." It is now time for the art to move on to a higher creative plane, with a professional language all its own, and a greater awareness of its potentials.

Heikki Seppä

ix

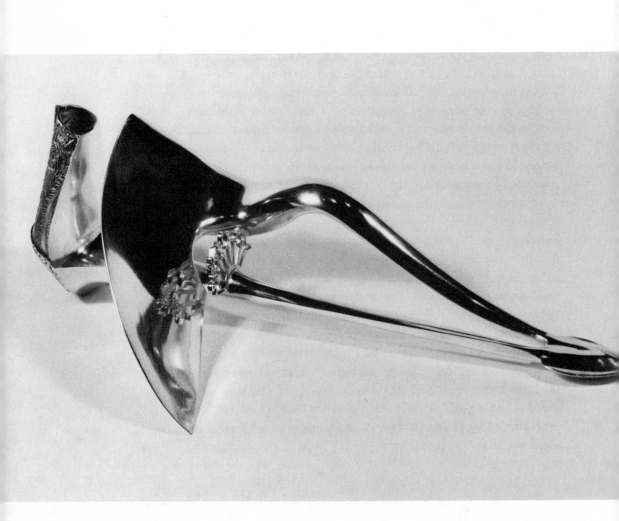

1

The Role of Formal Shells in Metalsmithing

THE THREE DOMINANT FORMS IN METALSMITHING

Before the advent of the machine age, metalsmiths were called upon to make a wide variety of hollow ware. In the course of their work, they made great use of the vast potential for developing new forms afforded by the metals they used. But as utilitarian needs came increasingly to be met by machine-made artifacts, there was less and less work for metalsmiths, with a consequent decrease in the development of new forms.

At present, there are but three basic volumetric forms dominating the work of metalsmiths, the *spherical* (usually in its more practical form, the *domical*), the *cylindrical*, and the *cubical*. From the standpoint of function, these are the stablest, strongest, and most useful forms. In addition to possessing a utilitarian horizontal/vertical stability, these forms have been experimented with aesthetically for centuries. The possibilities for further variations on them are all but exhausted, there being little chance to express new and unusual ideas within the framework of such limited choices. As a result, much of twentieth-century metalsmithing has relied on surface enrichment rather than formal development for its originality.

Although metalsmiths use the three dominant forms, these are identified by product names such as *cups*, *tankards*,

vases, *bowls*, and *boxes*, rather than by their generic names.
This stereotyping forces designers into preconceived notions
of their work. The preconceptions lie in the language being
used, the idea of a cup, for example, being limited to its
function rather than its form. But if, for instance, a domical
form were needed as part of a work, and the word *domical*
were used instead of the word *cup*, the utilitarian connota-
tions of the language would be removed. The generic lan-
guage would free the idea from the narrow limits of purely

functional considerations, clarify the concept, and make the processes involved more readily understandable. But because artists and designers have not adopted the generic language, they are not yet taking full advantage of the vast potential for developing new forms that the plasticity of metals affords, their creativity still being hampered by the limitations of the more traditional terminology.

FORMAL SHELLS

Formal shells, as the name implies, have a basic, easily understood structure that is predetermined and can therefore be very accurately prescribed. Such shells have the additional property of maximizing volume with respect to surface area. Their simplicity and stability have made them highly desirable for commercial purposes.

The methods for generating these shells can be extended to produce other forms which, though visually different, retain the same basic characteristics. From these additional forms, other, more dynamic, shell structures can be created by halving, quartering, or other kinds of subdivision of the original formal shell.

When this is done, the original generic name for the shell is lost, to be replaced by a functional one related to the shell's everyday use. Perhaps this is the reason for the low number of shell forms that recur in metalsmithing. By limiting themselves solely to functional concerns, designers stifle the possibility of artistic growth in other directions. By retaining the generic name of a particular formal shell throughout the design phase of creative metalsmithing, artists would not be limited by purely practical considerations in their work. Such generic terminology is readily available in good dictionaries, and will be used freely throughout this book.

Relatively few formal shells have simple geometric definitions, those that do being primarily the ones that can be produced by some sort of rotation. All such formal shells possess one or more kinds of symmetry. Since all forms are related to these basic geometric ones, it is best for metalsmiths to study them from this standpoint, as doing so will promote understanding of both formal as well as informal shells.

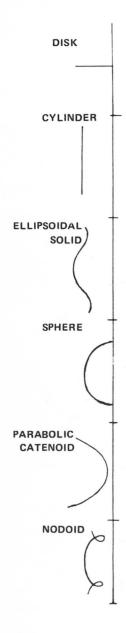

DISK

CYLINDER

ELLIPSOIDAL SOLID

SPHERE

PARABOLIC CATENOID

NODOID

There are only six surfaces symmetrical about their axes. They are rather closely related, movement from one to another being fairly easy. There are, however, wide variations in their aesthetic effect. Although a formal study limited only to these forms would be rather barren, a basic knowledge of them is indispensable for metalsmiths.

SYNOPSIS OF ROTATION SURFACES

Rotation of a radial line yields a disk.
Rotation of a line parallel to the axis yields a cylinder.
Rotation of an undulating line yields an ellipsoidal solid.
Rotation of a semicircular arc yields a sphere.
Rotation of a catenary arc yields a parabolic catenoid.
Rotation of a nodus yields a nodoid.

The sphere has the property of containing a given volume within the least surface area. It does not, however, lend itself to effective filling and emptying, this function being better served by the semisphere. Throughout the centuries there has been considerable use of this domical form, which is statically elemental, visually appealing, and suggestive of a certain functional efficiency.

THE LENTIFORM

The lentiform, in its various configurations, is useful in either its solid or, as shown here, its hollow form. It serves as a starting structure in the search for more dynamic and less stable forms. A view of its surprising potential can be gained simply by cutting into it. It is relatively easy to make from sheet metal, and permits a wider range of sizes than do other solids for a comparable work-time.

RELATIVE DIFFICULTIES IN MAKING CONCAVE, CONVEX, AND FLAT SURFACES

The convex, or positively curved, surface, is the easiest to make because the light reflected from it is concentrated into a narrow beam. This effect, coupled with a normal distortion, renders imperfections less easily detectable.

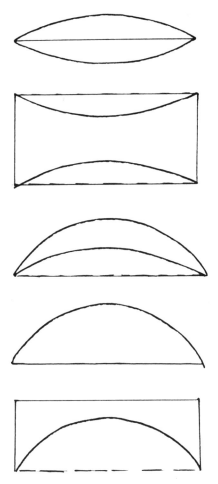

These basic compound curves represent all the known variations of the lenticular forms. The generic derivatives from Latin are: lens, lentiform, lentil, lentoid, lenticulate, lenticulated.

Next in ascending order of difficulty is the concave surface. Light reflected from such a surface is focused to a point and then dispersed beyond. The distortion is difficult, though not impossible, to detect.

The most difficult surface to make by hand is the flat surface. Its accuracy can be checked with great ease, since the flat, or nearly flat, surface acts as a mirror, and any distortion can be readily detected. Although in the past craftsmen made many fine mirrors and trays by hand, this would today be considered an enormously time-consuming task.

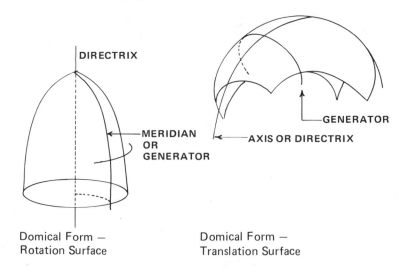

DIRECTRIX

MERIDIAN
OR
GENERATOR

GENERATOR

AXIS OR DIRECTRIX

Domical Form —
Rotation Surface

Domical Form —
Translation Surface

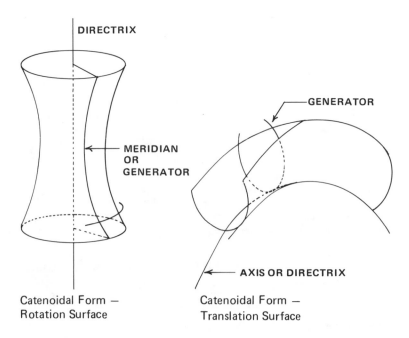

DIRECTRIX

MERIDIAN
OR
GENERATOR

GENERATOR

AXIS OR DIRECTRIX

Catenoidal Form —
Rotation Surface

Catenoidal Form —
Translation Surface

The **rotation surfaces** are formed by rotating a plane curve (meridian) about a straight line (axis) in such a way that the curve is concave to the axis.

The **translation surfaces** are formed by moving a plane curve (the generator) along the axis (directrix) in such a way that the generator and the directrix are curved in the same direction.

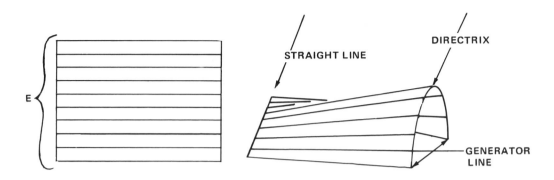

STRAIGHT LINE

DIRECTRIX

GENERATOR LINE

E

Conoid: The conoid is formed by moving a straight line along another straight line and a curved directrix. The generator line thus forms a shell resembling a half-cone, whence the name conoid.

Conic Section: A conic section is a slice from a cone.

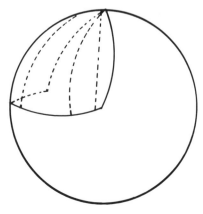

Spheroconic Section: A spheroconic section is a section of a spherical surface.

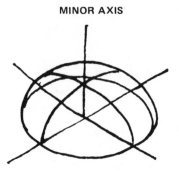

MINOR AXIS

Oblate spheroid: Ellipse rotated
about its minor axis

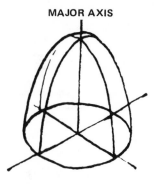

MAJOR AXIS

Prolate spheroid: Ellipse rotated
about its major axis

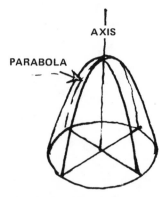

AXIS

PARABOLA

Paraboloid of revolution:
Parabola rotated about its axis

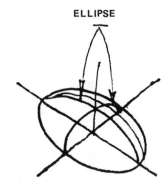

ELLIPSE

General ellipsoid

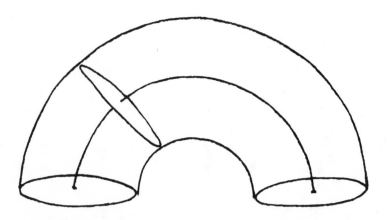

Torus: The torus is formed by moving a disk along an arc.

Toroid: A toroid is formed by translating a disk in any direction except along its own diameter.

2

Joining by Solder

JOINTS

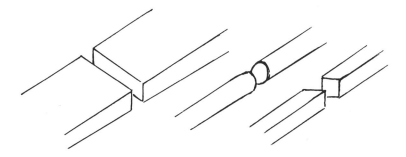

The butt joint is the simplest and weakest of joints. The better the fit, the stronger the joint.

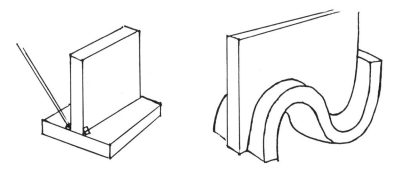

The tee joint is a joint in which a narrow edge is joined to a broad surface.

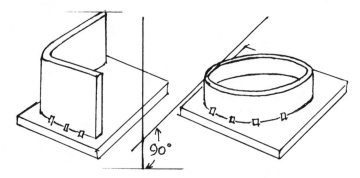

The corner joint is formed by a wall and a floor. Invariably the outside floor is cut away, thus eliminating the solder residue.

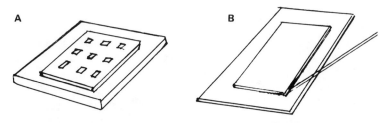

The sweat joint joins two flat surfaces. Figure A shows how solder in the form of paillons is melted on the smaller of the two surfaces. The two are then mated and heated until the solder flows in between. Figure B shows stick soldering.

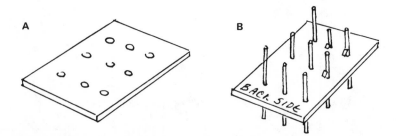

The stud joint is an accurate way to position slender filaments, wires, posts, etc., on a broad surface. Figure A shows holes in the plate. (Holes can be drilled quite accurately.) The wires are soldered from the backside, as in Figure B.

The spot joint consists of one surface touching another. The point of contact becomes the joint after it has been flooded with solder.

MAKING THE LAP JOINT

The slant should extend five times the thickness of the material. The slots in one end should be one material-thickness deeper than the facet. The soft but abrupt bend near the seam helps to steady it and keep it from warping during soldering.

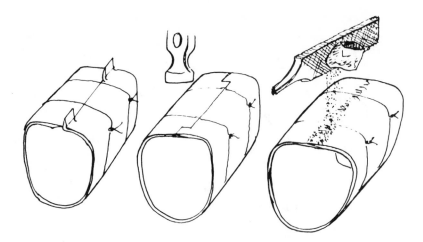

The taps stop the two slanted faces from sliding past each other so that tension may be exerted by the binding wires. The taps are then hammered down. It is beneficial to run a burnisher along the seams to press down the very edge of the facet. The cylinder is to be soldered from the inside. Charcoal dust is placed on the wet flux outside to keep oxygen away from the seam during soldering. The tie on the binding wire is placed on the side so that it will not upset the flatness of the seam area.

EFFECTIVE AND INEFFECTIVE DEVICES

Among the many securing devices, the tweezer (self-closing) on a stand is much abused. Its proper use is so limited as to hardly justify owning one; its improper use is so common that it is surprising anything is ever accomplished with it. The following are some typical violations:

1. Holding a wire hoop bracelet upright for soldering. (It is better to solder it flat, close to some heat-reflecting material.)
2. Clamping two semispherical halves together for soldering. (Since the tension is not released during heating, the work is vulnerable to collapse at the moment of highest heat.)
3. Spreading the jaws to hold a ring at its diameter during soldering.

There are numerous other examples of abuses of the tweezer-stand, but these point out the danger at the time of highest heat. The tweezer-stand is a fine tool, but only for a limited number of applications, and its use should be restricted to them.

Another useful tool is the mechanic's cotterpin, usually made of steel. Even after annealing, it may retain some tension that can damage weak parts. It is simple and often beneficial to make clamps resembling cotterpins oneself. The following procedure is recommended.

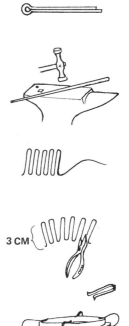

Take one meter of 1.5 mm iron wire (stovepipe wire) and flatten it somewhat with a hammer. Next, bend it into a zig-zag about 3 cm long with a pair of round-nosed pliers. Then simply cut each clamp off and anneal to build up the protective oxide.

Cotterpins made this way will last for years. They can be bent into many configurations, and it is good to have a variety of sizes and thicknesses on hand in the workshop. When they get smeared with flux, just pickle them and throw the pickle away. In the event that one of the cotterpins gets soldered into a workpiece, it is best to try to roll it off with a pair of round-nosed pliers. Flat pliers would tend to cut the iron before it begins to loosen.

TYING AND SECURING FOR SOLDERING — Temporary contact

It is not easy to tie two chicken eggs together, but once the proper method is known, the task presents no difficulty. In metalsmithing, one is confronted with tying problems many times more demanding than this, especially when dealing with the newer complex shells and the forms derived from them. To solve such problems, it is best to resort whenever possible to already proven methods.

We take for granted the knowledge that metals expand differently upon heating, and that the contraction during cooling is not uniform. There are also various stresses brought about by uneven heat-cool cycles, and anything subjected

15

to these forces must give a little. For example, in the use of binding wires, a straight, tightly bound wire spanning a space apart from the parent metal is still hot and vulnerable to breakage; contraction of the binding wire can cause a dent at the joining line, whereas even a little bit of give in the tying wires would prevent this. A considerable amount of foresight may be needed to prevent such occurrences.

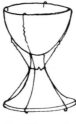

PROPER USE

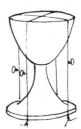

IMPROPER USE

Simple plane solder seams can be anchored with a buren raised thorn. This method is dependent on gravity or some other force to hold the two pieces together, but the anchoring thorns are usually strong enough to prevent any lateral

THORNS NEEDED ON AT LEAST 3 POINTS. MORE WOULD MAKE IT SIMPLER TO LOCATE.

THORNS ARE CUT FROM UNDER THE CONTACT POINT.

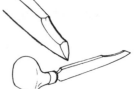

THE BUREN OR ENGRAVER

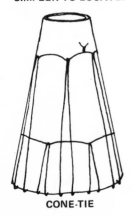

CONE-TIE

movement. The thorn itself should be raised from the surface that will be covered by the workpiece and the solder. Sometimes, for soldering purposes, a ledge is left and is then cut off later. In such cases, it does not matter if the thorns are raised from the outside.

The cone-tie is self-explanatory. It uses circumferential ties that are themselves held in place by longitudinal wires with the ends tucked under the edge.

The handle-and-spout-tie uses more wire to tie itself than it does to tie the spout. It is a very useful technique

16

that holds well and is very flexible in the amount of give after soldering. It leaves very little uncontacted wire, thus assuring the least amount of uneven cooling.

The rim-tie is interesting in that it uses a single piece of wire for the whole operation. It can be set up very quickly, holds well, and can be removed almost in a single rip. Efficient methods like the rim-tie save a great deal of time for the craftsman, and in so doing help to preserve the freshness and spontaneity of ideas that are so important to artistic creativity.

Pins, nails, and wires, when pressed into soft refractive materials like asbestos, magnesium, charcoal blocks, and soft fire-bricks, become effective fasteners.

Wire used for binding should not be thicker than the material to be soldered, otherwise it will leave its own impression on the workpiece.

In arranging the parts of a work for soldering, it is best to rely on the most natural, gravity-aided positioning of the components. Propping the parts in such a way that they support each other naturally often simplifies or eliminates altogether the problems of tying and securing. The surface tension of the molten solder and the capillary attraction between the metal surfaces are so strong that tying becomes unnecessary except to counter the effects of warpage. If holding devices are to be used, it is preferable that they be annealable; otherwise, they must be insulated from the heat.

If a work is to be planned correctly, every possible difficulty must be considered. Most difficulties arise in tying and securing for soldering. It is not unusual to drill holes for binding, to cut nicks into the workpiece in order to secure it at the time of soldering, to use temporary tack soldering, or to solder a temporary seam together. If, for example, oviforms are to be anchored together at a very odd angle for soldering, the surest way to keep them together is to drill a pair of holes, connect them with a pin, and then solder.

Holding hot parts together while soldering them is a vital aspect in the planning of a complex piece of work. Often, very ingenious solutions of joining problems go entirely unnoticed, even though much creative thought may have gone into them.

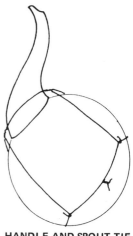

HANDLE-AND-SPOUT-TIE

RIM-TIE

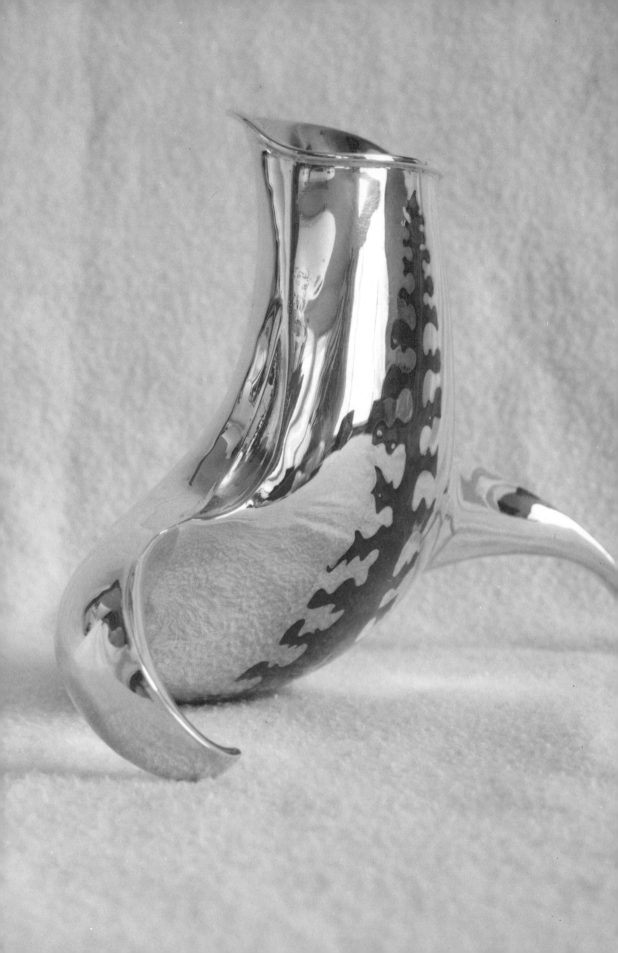

3

Raising Techniques

Before beginning the main discussion of this chapter, it would be helpful to review some terminology.

PROCESSES IN SHEET METAL FORMING

Angle Raising. This process progresses into indefinite angles that are later smoothed into a flowing surface. With this technique, a flat disk can be transformed into a three-dimensional volume with a hammer and a raising stake.

Annealing. A heat treatment to restore the normal crystalline state in a metal after work-hardening (q.v.). Softening a metal for further work.

Anticlastic Sinking. See *Sinking Techniques.*

Blocking. Hammering from the inside, generally used in synclastic sinking (q.v.).

Bouging. Shaping metal after it has been raised. Bouging is usually done with a wooden mallet, but it can also be performed with a hammer.

Crimp Raising. In this process, the crimps are compacted radially. New crimps are hammered over the old ones and compacted again. This process is usually done on relatively thin material.

Dutch Raising. This process begins at the edge and progresses toward the kernel (q.v.).

Edge Thickening. An extra operation performed to thicken the edge of a vessel being raised. This thickening is in addition to the natural thickening of the sheet as it is being raised. The edge thickening is performed across the lip with a cross-peen hammer while the workpiece is held in the lap, the armpit, or on a sandbag. It is usually done after each raising course and before each annealing.

Fluting. A decorative, radial patterning of the vessel wall.

Furrowing. Effecting a straight monobend along a strip of sheet metal.

Pickling. Chemical removal of oxides from the surface of a metal.

Planishing. Smoothing the metal surface with a hammer, usually done over a responding stake, the stake surface being larger than the mark left by the planishing hammer.

Sinking Techniques. These fall into two basic categories.
1. *Anticlastic sinking*, in which the two principal curves bend in opposite directions.
2. *Synclastic sinking*, in which the two principal curves bend in the same direction.

Snarling. Blocking (q.v.) with a device called a snarling iron.

Stretching Method. In this technique, a thick slab is thinned by pinching hammer blows, allowing it to develop into a volumetric form.

Synclastic Sinking. See *Sinking Techniques.*

Thinning Course. A kind of raising in which the artisan deliberately pinches the metal at the end of each charge (q.v.). That is, when the sheet metal has been driven to the point of contact with the raising stake surface, one or more blows are delivered to it so as to thin it slightly. A skilled craftsman can thus control the thickness of the metal as it is being worked on.

Twist. An internal or partial rotation in either direction on a piece of metal.

Work-Hardening. A change in the crystalline normalcy of a metal that occurs when malleability, ductility, or temper have played a part in the forming process.

FACTORS AFFECTING SHEET METAL FORMING

Bight. The amount of advance from one pass to the next, or the distance between two passes in the raising process.

Charge. The depth of hammer penetration during angle raising (q.v.).

Concentric Rings. Lines drawn around the kernel (q.v.) to guide hammering operations.

Course or *Coursing.* Usually, everything included in the raising process between two annealings.

Hammer Contact Point. The area of contact made by the striking hammer.

Height plus Diameter. The diameter of the starting disk if a volume is to be raised. If the vessel is to be sunk, the formula is the diameter plus half the height.

Kernel. A permanent mark struck on a workpiece from which measurements are taken during manufacture.

Klinker. A hammer blow in raising that is too heavy at the time the charge (q.v.) is driven in contact with the stake; a bad raising mark.

Pass. To move once around the workpiece with a raising or planishing hammer.

Positive Poising. A piece of metal is said to be positively poised when it presents a convex surface to the force striking it. For example, when the crest of a crimp is struck with a cross-peen hammer, the metal is said to be positively poised for the blow. If the metal presents a concave surface to the force striking it, it is said to be *negatively poised* for the blow, as, for example, when the valley of a crimp is struck with a cross-peen hammer.

Skin Diameter. The outside surface measurement from edge to edge through the kernel (q.v.). On a flat disk it is the same as the diameter; on a curved surface, always greater than the diameter.

Stake Contact Point. That area of the stake actively in contact with the work during raising, planishing, or bouging (qq.v.).

Stanza. The amount of work done between two hand-holds while raising; the shortest step of work; a series of several hammer blows on one hold.

Stress Lines. These are created either by working radially or concentrically in an inward or outward direction on a vessel wall. Their actual disposition is dependent on the relation between the hammer contact and the stake contact points (qq.v.).

RAISING ON A CYLINDRICAL SURFACE — Making a Catenoid

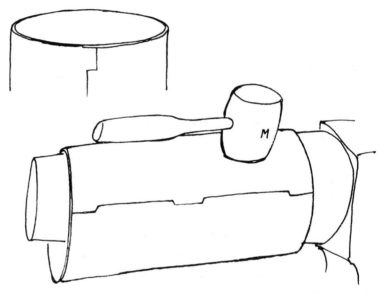

The lap joint is the only durable joint for raising and planishing. Its lapping edges tend to tighten when it is struck with a hammer, whereas other seams tend to crack, split, and fall apart. Once the seam is soldered it should be filed lightly and then planished. There should be no differences in the thickness of the metal in the seam area. The cylinder should be malleted round first, then annealed for uniform softness. A cross-peen plastic, wooden, or paper mallet is suggested for raising on a metal stake. Some artisans use a metal hammer when the metal being worked on is heavy.

It is both tiresome as well as injurious to perform the raising operation with a clenched fist. The raising hammer should be "thrown" at the target and picked up for a new blow only on its upward bounce. In this way, the hand is in least contact with the hammer at the time of impact.

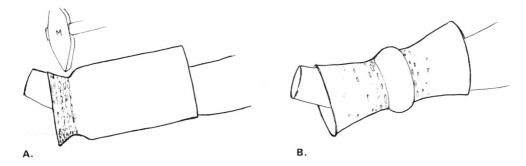

A. **B.**

Figure A exaggerates the results of the first few rows of raising. The stake may be either curved or straight.

The first coursing contracts the metal enough to leave a toroidal lump in the middle, as shown in Figure B. This can be dealt with easily, because the form can now rest on both sides of the lump.

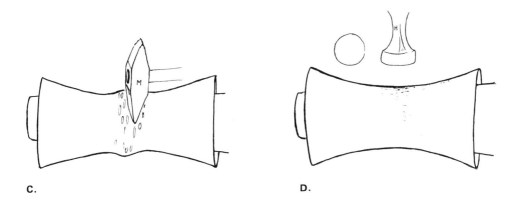

C. **D.**

In Figure C, the toroidal lump is almost raised in. It is quite possible to narrow the form more than is shown here. There is also a phenomenon worth observing: the narrowed catenoid, after raising, is somewhat thicker in the middle, the gain in the material thickness having come from the compression. If the raising is done with a metal hammer, the extra metal would go instead into the length, as there would be a slight pinch on every hammer blow.

For the planishing, a round, slightly convex hammer is used, as shown in Figure D. The catenoid should be loose on the mandrel-stake, otherwise it will stretch on every hammer blow. The planishing should be done in a very orderly manner. Once a pass is started, it should be completed fully around the catenoid, otherwise the surface will be noticeably uneven.

23

Many kinds of convolutions can be raised on cylinder walls, and the basic cylindrical structure can be used outright in a variety of forms, e.g., the cone, truncated cone, slanted cylinder and its variations, the vary-width cylinders, etc. All these monoshells are good starting structures, since they offer numerous possibilities for the propagation of new forms.

THE CYLINDER WALL — Closing One End by Raising Technique

The mushroom stakes of various sizes make excellent stakes for this type of raising operation. The tool should be a straight cross-peen hammer. A cross-peen wooden mallet works on large cylinders, but tends to flex the metal too much on small ones. The first coursing should be started fairly high.

The successive coursings are worked all the way to the top. The reduction thus gained thickens the metal considerably. For this reason, a metal hammer is better than a wooden mallet. The starting point for each coursing is one pass lower.

Finally, the hole is reduced to only one-quarter of the diameter. It is then planished in a rough way to make sure that the form is sized to the intended dimensions. If the lap joint breaks (a likely occurrence) simply solder it on the outside and continue raising. It is sometimes necessary to cut off crystallized broken edges before the raising is completed.

After planishing, the remaining hole is filed round and bevelled for the closing disk.

Cross-sectional view shows how the disk fits the remaining hole. Since the metal has gathered some additional thickness during the raising, the closing disk must match that thickness.

Shown here is the proper method for tying with binding wire. If the fitting is done properly, the tie does not have to be very tight. Notice the ends of the tie wires. Fluxing is done on both sides. On the inside, however, some powdered charcoal can be sprinkled over the wet flux. The charcoal will begin to glow during the soldering, consuming all the oxygen, and the glow will enhance the flow of solder on the inside face of the seam.

ANGLE RAISING — The Round Domical Form

Cut, preferably with a pair of snips, a disk whose diameter is equal to the height plus the diameter of the finished work. The edges of the disk should be filed so as to prevent injury. In the center, punch a permanent mark (the kernel) . After the first hammer blow, the kernel will be the only reliable point from which to take measurements. The kernel is so named because it is the point from which the whole project evolves. Since it is not always placed in the center, it cannot be called a center mark.

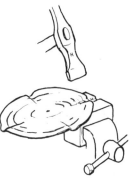

Use a soft cross-peen hammer. Start the crimping two-thirds of the radius from the edge. The radial crimping is done on an endgrain wooden block in a north-south-east-west fashion. This tends to prevent the crimps from getting deeper on one side than on the other. Since the crimping takes up more surface than the flat sheet, a doming effect is created immediately. It is important at this point to hammer the sheet in such a way that the kernel is left on the outside. This can be achieved by means of a large domical stake that can be used over a depression on wood or on a sandbag. Concentric rings should be drawn around the kernel with a pencil point, not with an instrument that will mar the metal surface, as scratches will have a tendency to develop into tears and ruptures.

The raising can be done without the crimping operation, but it is much slower. If the crimping operation is omitted, the first coursing is pre-ceeded by a slight sinking on the flat disk. The significant advantage gained from the crimps is that the metal thus formed is in such a position that the hammer blows compress the material to greater thickness (i.e., the metal is positively poised with respect to the hammer blows).

The beginning of the first pass is shown. Each successive pass is worked in the opposite direction in order to avoid a screw-like movement on the surface. In choosing a raising stake, it should be kept in mind that the supporting surface, or the stakehead, must be larger than the surface of the hammer. Each stanza should be worked over as many times as necessary to bring the sheet under it in contact with the raising stake. The edge pass is the most important one and should be done with extra care and uniformity.

Here the position of the hammer relative to the stake in the raising operation is shown. The stake can be metal or hardwood. Each successive coursing is started somewhat higher than the preceeding one, continuing until the edge is reached. Then a new starting point one pass lower is used until the area already in form is reached, and then the process is repeated course by course until the edge is reached again.

Bouging with a wooden mallet is done merely to even out the rough, lumpy results of raising. It is not done to form a dome, but rather to reveal the true form without the interfering lumps. It is most effective to use a large stake at this point, for if the support is too small, bouging is almost impossible. At this stage of the process, the metal is in a state of work-hardening, being springy and compressed. Further work on it in such a state would cause the metal to crack. In order to relieve the molecular stress, the metal must be annealed.

Firescale is a great nuisance in all volumetric work, silver being particularly vulnerable to it. To avoid a strong build-up during frequent annealings, it is beneficial to fill the form with charcoal and heat it until the charcoal begins to glow. This will consume all the oxygen in the upsidedown vessel and help to make the heating even. For purposes of annealing, it is best to use a neutral flame from a torch, as this tends to consume the free oxygen around the metal. After annealing, the work should be allowed to cool in the air, as this is the safest method. Quenching is permissible when a temperature of 150°C is reached. The best results from annealing are realized when the optimum annealing temperature is reached and the workpiece is "soaked" in this temperature, i.e., the temperature is maintained without raising or lowering for fifteen to thirty seconds. For large workpieces, a constant heat furnace that evenly heats the whole piece at one time should be used.

Cracks from flexing. An improper order in raising often causes flexing of the vessel body. When the piece is alternately hammered oval one way and then the other, the wall begins to fatigue and finally radial cracks develop on the edge. These cracks have very coarse crystalline faces which have to be cut before soldering. Usually a jeweller's saw is used to remove the inner face of the crack before the solder is introduced from the outside to fill the crack. Similarly, if a solder seam opens up on such a crack, it too should be cut with a saw or the crack itself parted sideways and scraped clean before soldering. Minute surface fissures are caused by the oxide layer (too heavy firescale), too sudden introduction of too high heat, the elasticity of an occasionally too soft wooden raising stake, or quenching in acid when the metal is too hot.

RAISING A CUBICAL FORM

To determine the material requirements, cut a sheet as shown. Raise the shaded corners ninety degrees. Since the material is excessive, some of it will have to be removed, and the problem is to determine how much and where. The drawing gives some indication.

Theoretically, the corners require no material whatsoever. In the figure, the circular arc cuts the diagonals of the corner square at one-third of their lengths, and is tangent to the side of the large square at its midpoint. The method for the location of the center point R of such circles is as follows: The points A and C are marked off one-third of the way down the diagonals of the corner squares. The point B is the midpoint of the side of the large square. Find the midpoints of the line segments AB and BC, and construct lines that pass through these midpoints at a right angle. The point at which these lines intersect is the point R. The construction is repeated on all four sides of the square. This is still just an approximation. Other factors, such as the depth, amount of blocking, and the manner of raising determine the final result.

Here the corners are crimped and the floor corners blocked out slightly.

28

Since the form is three-dimensional, the outline presented in this view is almost circular.

The raising is started from the corner. Each corner can be raised separately all the way to the top, flaring the raising pattern as it nears the edge. Once the four corners are raised and the form annealed for the second coursing, new crimping may be necessary to effectively gather the material. Eventually, the corner will be so sharp that no further crimping is needed. As the material is raised upward, it will increase in height and finally reach the top edge, as one would expect.

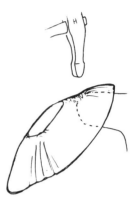

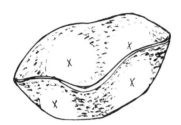

The metal to be raised must be **positively poised** with respect to the hammer blows. That is, a flat sheet cannot be raised in the manner described here. Consequently, the areas marked with an 'X' cannot and need not be raised. On the other hand, since the skin diameter always increases during the raising, the corners will be rendered tall enough to reach the top. A temporary roundness will also develop on the edge. This will not interfere with the total progress, as it can be straightened once the limits of raising are reached.

Once the forming process is finished, the piece is planished to its exact dimensions. It should be pointed out again that flat surfaces are the most difficult to make by hand, as any deviation from trueness is easily detectable.

4

Planishing Theory

WHAT HAPPENS

The relationship between the surface area of the hammer and that of the stake is illustrated. The hammer face is smaller than the anvil surface, but the force (downward) exerted by the hammer is equal to the counterforce (upward) exerted by the anvil surface. The counterforce, however, is distributed over a larger area.

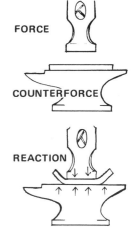

FORCE

COUNTERFORCE

REACTION

The metal absorbs the force and the counterforce resulting from the hammer blow. The anvil surface pushes upward where the force from the hammer blow is inactive. The hammer exerts a force downward only in the area of its surface contact, whereas the anvil pushes upward on the entire underside of the metal.

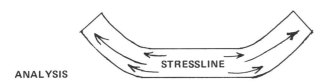

ANALYSIS

STRESSLINE

The outward and upward flow of the molecules determines the path of the stresslines. In a constrained situation, where the overall curvature is counter to that of the stresslines, the tendency will be for the metal to bend in the direction of the stresslines. In areas where the hammer blows leave marks on the surface, the anvil face is smooth. This phenomenon is accounted for by the overlapping of forces.

31

PLANISHING A ROUND DOMICAL FORM

The key to success in planishing is to be certain that the supporting stake contact is larger than the surface area of the hammer striking the metal (see A & B in the figure). In this way, each blow sets up a slight tension that is directed outward from the vessel. The result is a very smooth inside and a controllable series of facets on the outside. This is the proper way to planish. Theoretically, it would be possible to planish a domical vessel on a nail head, as long as the stake contact area is larger than the hammer contact area.

If the wall of a properly planished domical vessel were cut, it would spring open, indicating a tension outward. A well-fitting stake is important. If the stake is too flat, the tension will still be outward, but the result will be unevenness in both the interior and the exterior. When planishing is done on a convex surface, the hammer should be absolutely flat or imperceptibly concave.

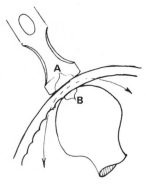

When the surface area of the hammer is larger than the contact area of the stake, the result is a lumpy exterior and an uneven interior. The passes, or rows of planishing, form welts inside that are almost impossible to remove. The welts may have to be cut out with a scraper, thereby resulting in the loss of a great deal of necessary materials.

If the planishing is done incorrectly, the stresslines do not create outward pressure. The tension is inward, and the vessel walls have a tendency to collapse. The vessel also has a lumpy surface.

WORK ANALYSIS

Planishing is a kind of work refinement which, when carried to its ultimate state, can render a surface as fine as a mirror. After the raising operation, the work is begun by coarse hammer blows at the rate of about forty percent coverage. During this phase of the work, the most likely fitting stakes are sought out. In this way, the workpiece is not totally committed to stakes that may look right at the outset, but later may not fit at all. *When the project is important enough, it is fitting that the craftsman make new stakes to fit the needs of the job.*

After the first "exploratory" planishing, the piece is annealed and left white, or matte, from the pickling. This will help in seeing the new hammer marks better. This time the coverage is increased to sixty percent, not counting the previous forty percent marks. The transition areas from stake to stake have to be overlapped very well, otherwise the typical transition welts will occur.

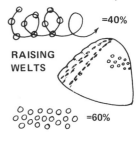

RAISING WELTS =40%

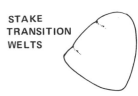

=60%

STAKE TRANSITION WELTS

Initially, immediately after the raising state, the raising welts should be removed in the forty percent planishing phase. This is best done across the welts. In a round domical form, the planishing may be radially or concentrically oriented. In a cylindrical form, a triangulation of the planishing marks is employed. Triangulation is effective on other forms also, for planishing as well as to check the forms themselves.

TRIANGULATION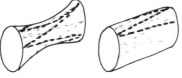

Since the edge of a workpiece is very vulnerable to stretching during planishing, it is left undone until the last pass. The last few millimeters of the wall can thus be controlled, and often times eliminated during the final trimming.

When the planishing coverage begins to take one hundred percent of the surface, it is a good idea to fix a light source in the room in such a way that the light beam reflects from the spot where the hammer lands directly to the planisher's eye. It is amazing how much this will help in seeing the surface.

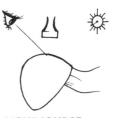

LIGHT SOURCE IN THE ROOM

Planishing should be done in a position that is easiest and most comfortable for the craftsman. As always, good work habits produce good results. The hammer acts as an extension of the hand as well as a "checkvalve" against reverberations. The handle should be in a straight line with the forearm, and it should be held loosely. As explained previously, the hammer should be thrown at the target, released almost at the point of impact, and picked up again on the upward bounce. Soapstone or talcum powder help in maintaining a loose hold on the handle.

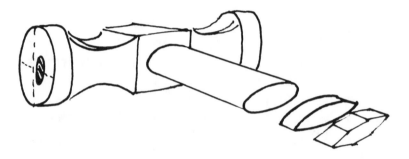

The figure illustrates some of the fine points of the planishing hammer. Note the handle cross-sections and the place of contact on the peen, which may wear so as to be slightly concave. A well-balanced hammer has a directionally mounted handle. A well-used hammer develops a small concavity at the point of impact. This is very beneficial to good planishing, but is also very individual, its usefulness being limited to the craftsman who wore down the concavity. Stakes also have such an optimum spot, and therefore must be constantly moved during the planishing process. Work is seldom held stationary on the stake.

Fallacy of the Perfectly Fitting Stake. There is no such thing as a "skin-tight" solid stake. As soon as the first hammer blow is delivered, the stake is no longer skin-tight, because the metal will have stretched away from its point of contact.

Use of Pitch. Complicated hollow forms can be filled with pitch and planished over. This is not true planishing, but could be called a kind of forming, akin to chasing, although it is done with a hammer.

One-row-concentric planishing. This type of planishing creates a continuous ridge between the rows. This can be avoided by resorting to the circular, spiroidal pattern of planishing

described above. The circular pattern covers a wider path and yields smoother results with fewer courses of planishing.

Planishing Marks as the Final Finish. Surface scratches are unavoidable during the raising and planishing operations. The scratches cannot be removed by hammering, but must be ground and polished away from the surface before attempts are made to decorate it. For such purposes, a well-polished, scratchless metal surface and a well-polished, slightly convex hammer peen are essential. A wide variety of handsome surface treatments is possible with different hammer peens.

CHOICE OF HAMMERS AND THEIR USE

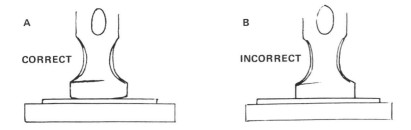

A	B
CORRECT	INCORRECT

Theoretically, it should be possible to planish a flat surface with an absolutely flat hammer. In practice, however, human error makes this impossible. In order to compensate, a slightly rounded peen should be used, the degree of roundness depending on the skill of the metalsmith — the greater the skill, the smaller the degree of roundness needed.

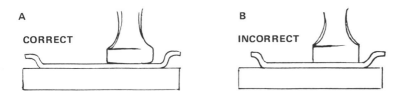

A	B
CORRECT	INCORRECT

Impounded work presents a more difficult surface problem. The flat surface is not free to expand laterally, and so the boundary must be enlarged as the surface area increases during the planishing. The tension is first set uniformly at one side, and then countered to the neutral flatness from the other. As with all flat surfaces, the best way to test it for trueness is to use it as a mirror. Any deviations will be readily detectable.

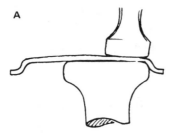

These illustrations show that an absolutely flat hammer is not suitable for flat work. Such a hammer leaves its own edge on the workpiece, destroying the necessary accuracy. Figure B shows improper use of the flat hammer in trying to bring a slight bulge under control.

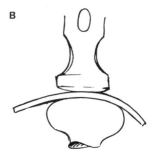

The flat hammer is correct for use on all convex surfaces, as it is the closest form that can be used on sheets that bend away from its own flatness. Figure B shows an incorrect choice of hammer for a convex surface, provided that the aim is to smoothe the surface rather than to texture it.

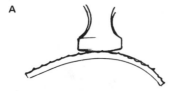

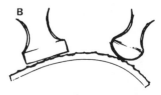

Surfaces with heavy forging or raising marks are best planished with a convex peen to get them into a semi-rough state. As Figure B shows, the flat and the too domed peen are incorrect choices; the flat peen cannot penetrate, and the domed peen would stretch the metal too much.

In planishing as well as in raising, the sheet metal is in a "plastic" state. Hammering one area more than the rest will create a bulge. This kind of stretching must either be absorbed into the form, or else raised back to its original dimensions.

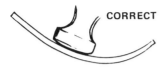
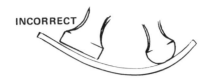

CORRECT INCORRECT

These illustrations show the correct and incorrect uses of hammer faces.

Since hammers can be used as stakes, and vice versa, their proper role should be understood. Variations and exceptions prevent one from drawing hard and fast rules, but these pages should at least suggest a careful study of tools before their use.

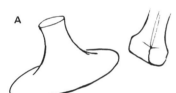
A
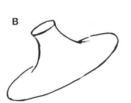
B

The hammer in Figure A should be used for the workpiece shown, as its form most nearly coincides with that of the workpiece. The hammer in Figure B is an incorrect choice because the cross-peen curve bends away from the workpiece.

Although it may seem that concave hammers would be ideal for use in many instances, in practice their application is limited by human error. One is thus forced to make compromises in order to meet the great variety of needs encountered on various work surfaces. The realization that surfaces can be hammered from both sides (e.g., shell structures) increases the utility of hammers. Figure A, at right, shows the correct hammer for the illustrated workpiece. Figure B shows some incorrect choices of hammer for cylinder planishing.

A

B

A

B

In this very demanding anticlastic form, the surface changes its curvature from one place to another. The correct hammer choices are shown in Figure A. Incorrect hammers, such as those shown in Figure B, could ruin the piece.

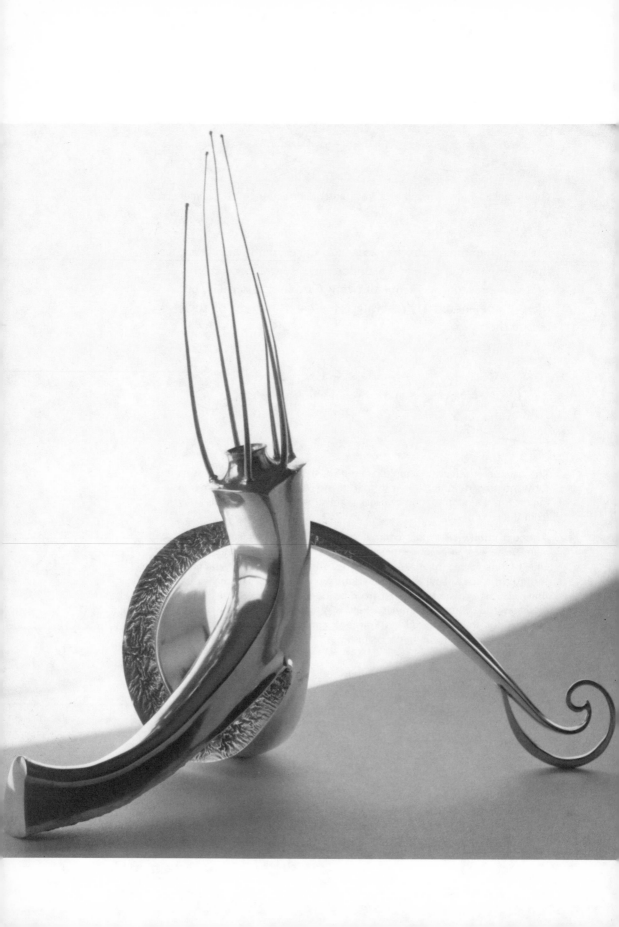

5

Layouts

LAYOUT FOR THE TRUNCATED CONE

Draw the exact dimensions (height, upper diameter, and lower diameter) of the intended figure.

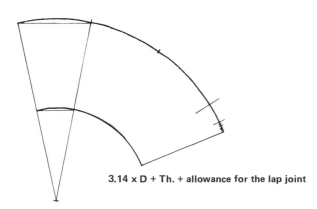

3.14 x D + Th. + allowance for the lap joint

Extend the side lines to the point where they converge. From this point, draw two circular arcs whose respective lengths are 3.14 times longer than the diameter, plus one material thickness, plus five more material thicknesses for the lap joint. Cut the layout from the sheet metal with a saw or snips. Make and solder the seam. If much hammer work is to be done, it is best to use the lap joint. If the cone is small (for example, those in which a gemstone is to be set) a simple butt joint is sufficient.

The finished truncated cone will possess the exact intended dimensions.

LAYOUT FOR VESSELS TO BE RAISED

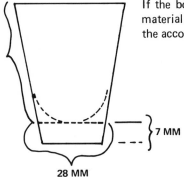

If the bottom is to be closed by raising the wall material into it, extra material must be added to retain the desired height of the vessel. See the accompanying diagram.

7 MM

28 MM

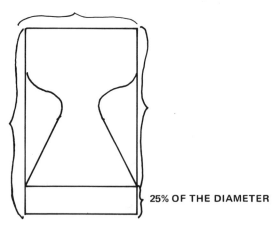

25% OF THE DIAMETER

In this example, the cone, developed from the cylinder, will produce more than enough material for the bottom of the upper cup. Depending on the craftsman's work habits, however, the material may well gather extra thickness, in which case the calculations will not hold true. For this reason, an extra twenty-five percent of the diameter is added to the starting material.

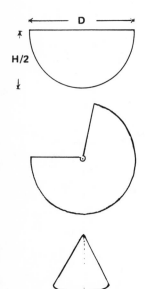

D

H/2

LAYOUT FOR SINKING AND BENDING ROUNDED FORMS

The semishpere is a good form for which to examine the material requirements when the sinking technique (i.e., working the metal from the inside) is used. The formula for the diameter of the starting disk is the diameter plus one half the height of the finished vessel. The formula is varied only by the thickness of the metal and the depth of the sinking. Generally speaking, sinking should not exceed fifty percent of the diameter. If more depth is desired, one should resort to the raising technique, or else to the stretch method, which starts with a thick slab.

An explanation of the requirements necessary for bending a form would include much more detail than will be given here, as the purpose of this book is to deal with the curvilinear rather than the flat. A sector is cut from a disk, determining the height and diameter of the cone. Note the presence of the clearing hole in the center, without which bending would be impossible.

LAYOUT FOR DOMICAL FORMS TO BE RAISED

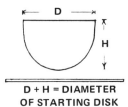

D + H = DIAMETER OF STARTING DISK

The diameter of the starting disk for round domical forms is the diameter plus the height of the finished vessel. This formula yields a disk with a surface area approximately equal to that of the finished vessel, the approximation being close enough that differences between full and slim vessels are hardly worth the bother of calculating.

Different forms using the same starting disk formula. Great differences can, however, arise from errors in raising, such as hooking blows, or outwardly glancing blows, that either stretch the metal too thin, or else cause it to thicken too much.

SKIN DIAMETER

The material requirement for crimp raising is the whole skin diameter. Crimp raising is not true raising at all, as there is very little, if any contraction of the metal. Instead, the sheet is crimped and compacted repeatedly to form a vessel.

LAYOUTS FOR FOLDED AND SEAMED CUBES

The layout shown here for the cube is accurate, but when the thickness of the metal, the cutting, and the scoring are all inaccurate, the result is far from exact. The scoring of all the folds results in very hard, controlled corners, but the scoring itself is difficult to control. In a small cube these errors will seem disproportionately large, whereas they tend to be absorbed in a large cube. Mitering the panels is of no help if the panels cannot be held in place while soldering them together.

The method illustrated here is recommended for cubes measuring five centimeters or less. It accomplishes the job more rapidly and involves fewer headaches. Bend a strip of metal around the four corners and place the seam away from the corners. In this way all the corners will be equal. Solder an oversize top and bottom and cut the excess off. Allow for the material thicknesses in the height measurements. It is important to drill a spiracle in the structure, otherwise it will explode during subsequent heating.

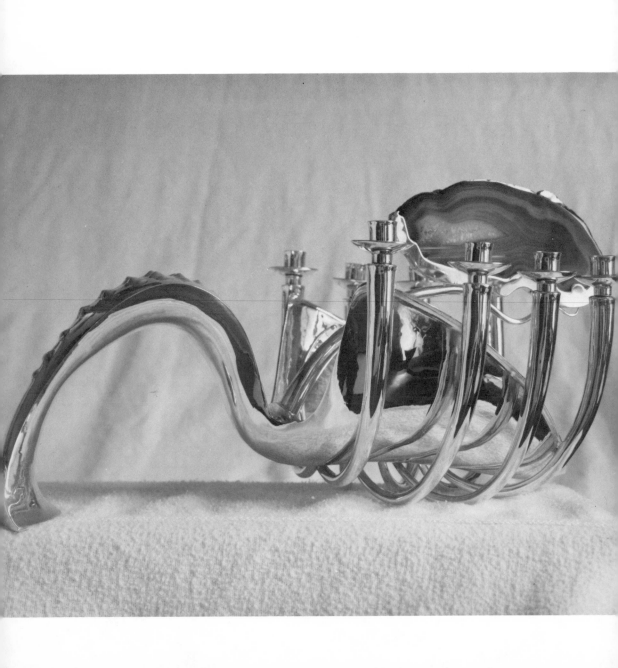

6

Eccentric Tubing, Hinges and Linkages

BASIC PRINCIPLES

Round Link Type

The simplest and most readily understood type of linkage is the loose, round-linked chain. It permits very free movement in all directions, and will not tangle up in unravellable knots. It is an efficient use of metal, but in order for it to be well made, its links must be opened and then permanently closed by fusing or soldering.

Strap Type

Another type of linkage is based on forms that can be fitted together without any fusion problems. There is a vast number of variations of this type of linkage. Its twist movement is poor, but is compensated for by the axial movement.

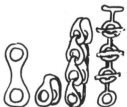

Ball and Socket Type

Ball and socket linkage permits unlimited twist movement and very smooth axial movement, but its radial movement is restricted. In its compactness it is visually pleasing, and structurally it is quite strong. There are many excellent applications of this type of linkage.

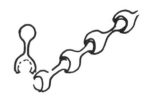

Universal Coupling Type

Universal coupling does not permit twisting, but allows for unlimited movement in all other directions. Its design may be very simple or quite complicated.

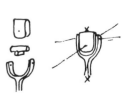

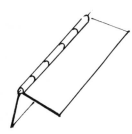

HINGES

Hinging is another limited type of linkage, permitting only back and forth movement. Hinging usually relies on a third part for its function, the two principal parts to be linked being joined by a pin that ties them together.

Hinges, of course, facilitate the movement of parts, but their role is more than strictly functional. A well-made hinge adds greatly to the tactile and kinetic experience of a piece of work. Although there is basically only one principle involved in hinges, countless variations occur in different fields of manufacture. Those found typically in metalsmithing are enumerated here.

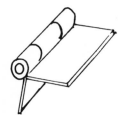

The surface hinge is an inferior, uncomplicated device. Its cheniers are attached to the two parts with only minimal joining.

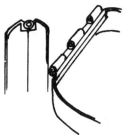

The sunken hinge is a typical cradle hinge. It serves as the basis of all fine handmade hinges and is very versatile, having straight-wall applications as well as many other uses. The degree of opening can be regulated by the depth of the cradle.

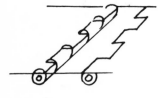

The hidden hinge is a deep cradle hinge with its cheniers made of very heavy-walled tubing. Here, the eccentric tubing is used to offset the hole in such a way that the part that is to be cut flat receives the heaviest tube wall. The cover panels are often soldered on after the hinge proper is made.

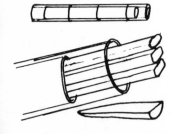

The spring hinge is an ordinary hinge with an even number of cheniers. The connecting pin is a tube, barely extending from one end chenier to the other end. Through this, a set of torsion bars (at least three) are run. One end of the set is fastened with a small wedge, while the other is twisted a half turn or more and then fastened. This gives the necessary tension to open the two halves when the locking mechanism is released.

Helical and disk hinges are additional examples of the many variations on the linkage principle.

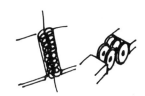

THE OFF-SET HINGE USING A CONTROLLING CRADLE

The off-set hinge is used when it is desired to set the links farther apart than is possible with other types of hinges. The off-set hinges can be made separately from the main structure and used in various ways afterwards. The illustration shows a typical off-set hinge.

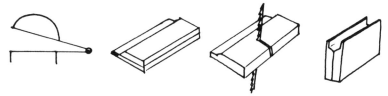

The base of the cradle can be made from one solid piece or from two pieces soldered together. Some rough filing, or forming in other ways, can be done at this stage.

The cradle blank is formed as closely as possible to the size of the tubing before cutting it in half.

The two halves are then glued together for sizing. At this time, the tubing should be slightly larger than the cradle itself.

The filing should be done with a round parallel file and not with a round taper file. There are flat, round-edged files that are much stronger, but the final trimming is best accomplished with the round parallel file.

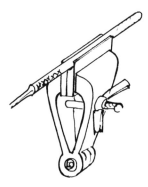

When the cradle is large enough to let the tubing fit snugly inside it, the two halves are separated. With the tubing inside the cradle, the depth is gauged and adjusted to permit the necessary amount of opening of the hinge.

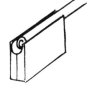

Normally, the amount of movement in a hinge is ninety degrees, but this varies depending on the application. The deeper the cradle is, the less the amount of opening.

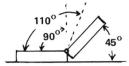

The actual length to be divided into equally long cheniers should be measured so as to be one tubing diameter longer at each end.

After cutting the cheniers a bit longer than the total length, a chenier caliper is used to square the ends of each chenier.

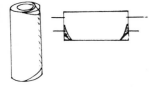

The part of each chenier that will be subjected to the solder (i.e., the corners) should be trimmed off. This permits the solder to flow normally within the parameters of the chenier without interfering in the place provided for the corresponding chenier.

The fit, the overall length, and the range of movement are checked with a loose pin.

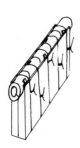

The individual cheniers are tied, the seam of each is rotated towards the half-cradle, and the pin is removed. Next, the whole bundle is heated to 150°C (test with moisture: water boils at 100°C), and wet flux-coated solder snippets, or paillons, are placed on the joint. The moisture in the flux will boil with a hissing sound and will not permit the flux to flow into the seam, but will keep it directly under the solder. (To make sure that no solder flows into the seams, one strand of horsehair is put into the tube. As the hair burns, it coats the immediate surfaces with sulphurous fumes, preventing the solder flow.) Heating is continued until the solder melts, thus tack-soldering the cheniers temporarily into their exact places.

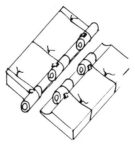

The binding wires are removed and the halves carefully separated and pickled. Next, they are retied individually and properly soldered. The careful squaring of the ends, the removal of the lower corner of the cheniers, the extreme placement of the cheniers, and the solder used to unite the cradle blanks, all of these now come into play in the joining procedure.

All the surplus solder is filed off and the halves are returned to match one another. A semi-tight steel pin is inserted and the function checked. The hinge will probably be tight in places, but gentle hammering along the cheniers will adjust this, as well as cause the metal to flow into the voids. Hammering on both sides will aid in the fit.

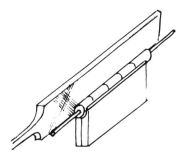

A hard-drawn pin of metal different from the hinge and slightly oiled is inserted tightly to line up the cheniers. The function is aided by filing the whole hinge finely.

The final pin is made of a foreign metal. It is flattened at one end very gradually to the extent of half the length of the end chenier. For purposes of repair, the pin is anchored at only one end. If the pin were anchored on both ends, the whole hinge would have to be destroyed upon removal of the pin. The pin should be made stationary, or else it will work itself out. Once the pin is drawn tight, the surplus material is sawed off or filed smooth. It has also been the practice to cut the actual pin short and cover the end with a small piece of wire made of the same material as the hinge in order to retain the integrity of the work.

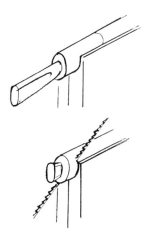

ECCENTRIC TUBING FOR BETTER HINGES

Strange as it may seem, the hinge, an intricate mechanical device, is best made by hand even today. In fact, handsome hinges made by master boxmakers feature fittings so tight that the various separations of parts can hardly be seen by the naked eye. Their function is a pure delight to experience; there is no place where the lid becomes suddenly loose or tight; all the parts move with a smooth, even kinetic friction. In all concentric hinges made with a sunken cradle, however, it is likely that the cradle, regardless of how well fitted it is to the tubing size, will not fill evenly but will leave a gap on each side of the chenier. This is caused by the fillet of solder necessary to secure the cheniers. In order to compensate for

the shifting of the tube or chenier hole, an eccentrically placed hole in the tube is used. The construction is done as follows:

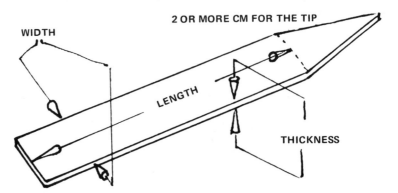

Take the full length required plus two or more centimeters for the tip. Calculate the thickness of the strip to be roughly thirty percent of the diameter of the finished tubing. The width is 3.14 times the diameter. This should be estimated to be oversize according to the amount of eccentricity of the hole. Trim the sides as parallel as possible. This will keep the seam straight and on one side of the tube.

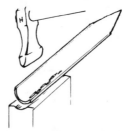

Furrow very carefully, starting close to the edges.

Make the point tubular, not just a flat fold. Close the tubes as much as possible with a hammer. There is, however, no point in overdoing it, as the drawplate will close it more efficiently.

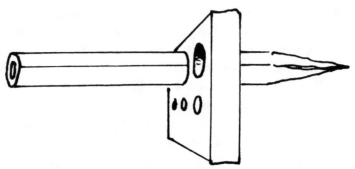

Draw the tube until the seam is closed tightly.

File the seam flat with a fine file. At least fifty percent of the thickness should be removed.

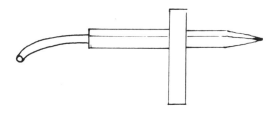

Put a soft-tipped, slightly oiled steel wire (piano, guitar, etc.) of the desired I.D. (inside diameter) into the tube. Draw until the outside is round again. File the seam flat again, if desired, and draw anew until the final size O.D. (outside diameter) is reached.

With the corner of a file, cut small diagonal marks across the seam. These will not only show the seam when the tube is cut into short sections or cheniers, but will also help the solder flow across the seam. Remove the steel wire by pulling it out against the drawplate from the reverse side in the nearest loose hole.

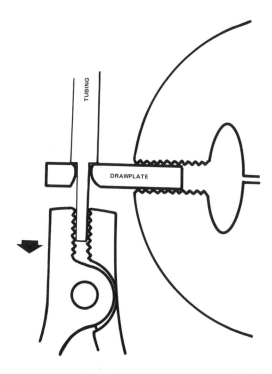

EXTRACTION OF THE STEEL MANDREL FROM A TIGHTLY DRAWN TUBING

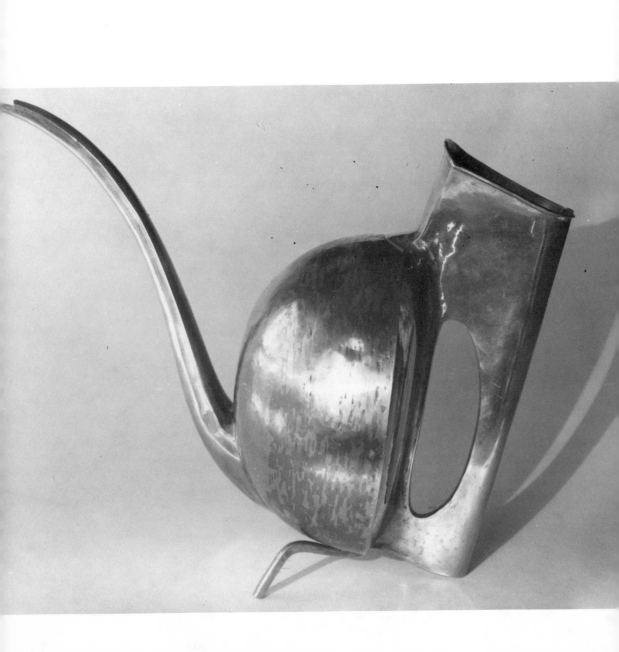

7

Surface Enrichment, Refinement and Finishing

There are three categories of surface refinement:
1. The additive method, which involves the use of plating or other chemical means to alter the metal's surface.
2. The nonreductive method, which involves the use of hand tools, including burnishers.
3. The reductive method, which involves the use of abrasives.

The reductive method is the principal technique used in metalsmithing. Several conditions play a part in determining the results of abrasion. In the right combinations, these conditions provide fast and effective ways of working, and permit a wide variety of finishes in metal.

The conditions affecting surface abrasion are:
1. Effectiveness and efficiency of the abrasive
2. Physical and chemical properties of the vehicle
3. Hardness, resiliency, porosity, and material content of the carrier
4. The surface speed (in centimeters per minute, or cpm) of the carrier
5. The pressure applied, which gives rise to frictional heat
6. Direction, changes of motion, and sweep

In every workshop there are circumstances that affect, favorably as well as unfavorably, the results of surface refinement. Included among these are lighting, ventilation, cleanliness, work safety, etc.

When the filing process has been completed by a careful crossfiling through a range of files from coarse to fine in such a way that the surface is uniformly covered with file marks, the abrasives are used to further the refinement. Abrasives usually belong to the class of compounds known as oxides. Among the more durable abrasives are the aluminum oxides, silicon carbides (carborundum), calcium carbide, tungsten with carbon (carboloy), tin oxides, iron oxides (jeweler's rouge), chrome oxides, and other man-made abrasives, and a host of natural rocks and sands, such as pumice (silica-bearing lava), granulated garnet (sandpaper), silica-limestone-flinty quartz (tripoli), flintsands (trent sand), etc. Frequently, several oxides are combined to make different grinding and polishing compounds.

Abrasives are classified according to grit number, which is a measure of the number of particles per unit length. Thus, coarse grit has a low number and fine grit a high one. The highest of the grit numbers is 600. Anything with a higher grit number is classified as powder or polishing compound.

THE VEHICLE

The oxides from which abrasives are made are loose powders or fine dust, which must be held together for ease of handling. The substances used to bind the abrasive grit together are called vehicles. Among the materials used for vehicles are polymeric resins, glues, paper, rubber, grease, oils, lard, water, and, in some cases, air.

The material from which the vehicle is made must be less abrasive than the particles it holds. When oils of various viscosities are used as vehicles, the purpose is not only to keep the abrasive from dusting in air, but to keep the particles in suspension so that they are free to rotate and expose new cutting edges to the surface being worked on.

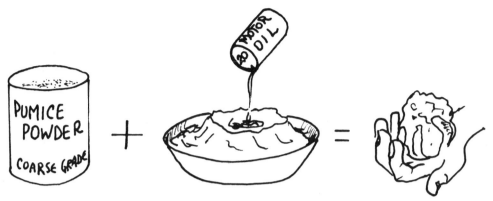

ABRASIVE, TO WHICH THE NECESSARY VEHICLE IS ADDED, MAKES THE COMPOUND

Today motor oils are plentiful, but are tough and difficult to clean afterwards. Mineral oils or cooking oils work off easily in detergents.

THE CARRIER

Various devices, ranging from mechanical vibration to driven wheels on to hand-operated trumming strings and sandpaper are used for the transmission of motion necessary in grinding and polishing. The most primitive example is the stone, in which the vehicle and the carrier (i.e., the transmitter of the motion) are the same. In the case of sandpaper, the glue holding the grit is the vehicle, and the paper is the carrier through which the motion is transmitted from the hand.

Selection of the best carrier is a constant concern. Although there is a multitude of possibilities from which to choose, it is difficult to find the one that has the desired degree of hardness or resiliency. For example, hard, medium, and soft woolen felt wheels for use with pumice/oil compounds work very well with tripoli and some rouges, but are not suitable for final polishing. Leather and cotton are often used for this purpose.

The felt wheels can withstand relatively high centrifugal forces. Well-made wheels run concentrically and have an excellent porosity that holds the compound for a very long time. As long as the wheel is charged with abrasive compound,

it wears very little. The more durable hard materials are designed to be used as carriers on very fast rotating wheels to counteract the extreme centrifugal force.

During the grinding operation, a substantial amount of material is removed from the metal's surface by abrasion. The abrasive grit itself wears down, breaking into smaller particles. The surface of the metal is thus marred by the coarseness of the abrasive being used. If the smaller particles are used over again, they in turn render a finer surface. In practice, the hardness of the metal would cause this process of wearing down to be too slow. The metal surface can be refined to a mirror finish more quickly by switching to a finer abrasive. Certain reasonable steps must be taken, however, as only a few grit numbers are proper for a given type of work, and these must be carefully chosen.

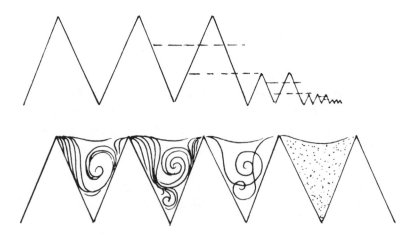

In theory, if uniform file marks can be removed with a given grit by going over the surface three times, it means that the marks left by the grit are one-third the depth of the original file marks. Continuing this procedure, it can be assumed that after three applications of the given grit, the surface will be twenty-seven times finer than the file marks. On the other hand, if a compound that cuts too slowly is used, the compound itself is scraped off the carrier with every contact. This is counterproductive as it rolls the compound into eddies, abrading the walls of the grooves of the surface and making them even deeper.

The final power polishing resembles burnishing. The crystalline structure at the surface of the metal is upset by the fast-moving abrasive. This generates an intense frictional heat at the point of contact, causing the crystals to flow in the direction of the motion, thus bringing the flat side of the crystal in line with the surface, making it appear shiny.

Fiber Wheels

There is a great selection of fiber wheels. Natural fibers like cotton (muslin), wool, bristle, leather, and wood are all used to make carriers for abrasion. They are generally preferable for higher speeds because they can withstand the higher temperatures better than the synthetic fibers.

Woodlaps are excellent carriers, provided they are used all the time, since allowing them to dry causes them to shrink out of the round. With emery and water at 22,500- 25,000 cpm, they serve well in grinding enamels.

Leather wheels and bobs are fine finishers. Walrus hide wheels are still considered the best for use with pumice and tripoli, but other leathers serve this purpose well also.

Cotton, usually tough muslin, is a cheap, well-wearing, and versatile carrier material. It can be sewn tightly to make a semi-hard wheel, or used in a loosely tied wheel for a great number of purposes.

Bristle brushes are used to achieve uniformity of surface conditions rather than for actual grinding and polishing. Their resiliency often permits work in more difficult places than would be possible with solid carriers.

THE SURFACE SPEED

Motion causes wear on surfaces that are in contact with one another. If the motion is increased, the wearing process is speeded up. If abrasives are added to the process, it is speeded still further. In addition, certain substances wear down more rapidly than others.

Each of these variables figures in the determination of the optimum speed or motion for the most efficient use of a given abrasive on a given metal. The requirements imposed by these variables can be met by mechanical means. In the case of shafts and spindles run by electric motors, the number of revolutions per minute may be altered by means of a variable speed motor, or else by changing the pulley system so as to deliver the desired number of revolutions per minute.

When the necessary number of revolutions per minute is achieved, the surface speed of the abrasive wheel becomes important. At a given speed, a large wheel will deliver more centimeters per minute than will a small one. The number of centimeters per minute delivered by a wheel of a given diameter moving at a given number of revolutions per minute is calculated as follows: Multiply the diameter of the wheel by 3.14 and then multiply the result by the number of revolutions per minute of the spindle.

Example: Suppose a felt wheel with a diameter of 10 cm is on a spindle set for a standard 1,725 rpm. Then

$$3.14 \times 10 \times 1,725 = 54,165 \text{ cpm}$$

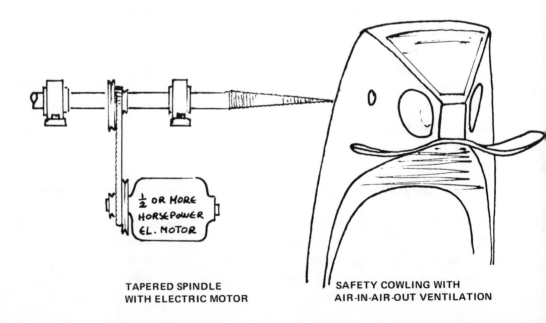

TAPERED SPINDLE
WITH ELECTRIC MOTOR

SAFETY COWLING WITH
AIR-IN-AIR-OUT VENTILATION

The ideal working range for pumice and oil compounds on nonferrous metals is 40,000 to 60,000 cpm. The working range for the coarser abrasives such as 180 grit aluminum oxide on nonferrous metals is 40,000 to 50,000 cpm.

The ferrous metals can be ground with coarser grits at much higher speeds. The effective range is around 160,000 cpm, which is also good for the middle range polishing of many nonferrous metals.

The final, highest polishing on sterling silver requires surface speeds up to the 200,000 cpm range.

All these calculations are subject to variation because of the need to change the sizes of wheels and bobs during the work without having the facilities to change the rate of the spindle. While the optimum circumstances can readily be determined in theory, there are still a great many variables that enter into practical considerations. For example, small steel burrs work best at lower speeds on nenferrous metals.

The theoretical surface temperatures are often ignored in the use of flexible shafts in which the revolutions are as high as 14,000 rpm. Sustained use of the wheel under such conditions would soon burn it up, but the nature of the work is such that the wheel has ample time to cool between the sweeps.

THE PRESSURE APPLIED

The momentary frictional heat, which is produced by the high surface speed and the pressure of the workpiece against the wheel, is very important in the final polishing, when the removal of metal is at its lowest. A loosely sewn buff can be "stabbed" momentarily with the workpiece, especially when deeper penetrative polishing in more complicated areas is desired. Many polishing compounds, such as tripoli, use lard or heavy grease as a vehicle. Such a compound may stick to the workpiece, but with adequate surface speed, proper "nap" on the wheel, and the correct pressure, the compound sticking can be prevented.

DIRECTION OF THE SWEEP

In many instances, only one direction is available for the wheel to enter a section of the workpiece. But when the surface is available for broad, generous sweeps from the wheel, it is best to change the direction forty-five degrees from that of the previous sweep, as shown in the figure. Direct ninety degree attack is less productive.

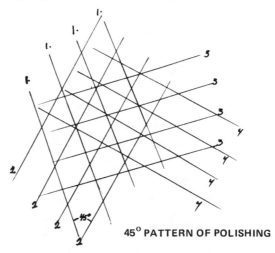

45° PATTERN OF POLISHING

The larger the wheel, the larger the contact area, and the better the surface provided. On the other hand, if a very soft wheel is used, and an attempt is made to increase the amount of surface by increasing the pressure applied, the contact point will be destroyed because it will deflect away from the work surface, thus making matters even worse.

ROTATION

TOO HARD PRESSURE CAUSES EXCESSIVE DEFLECTION ON THE CARRIER WHEEL.

TRUMMING — Reductive Method, by Hand

Strings, tapes, ropes, anything flexible, in fact, can be used for trumming when charged with abrasives. The surface speed that can be generated by back and forth motion either of the piece or by see-sawing the string itself over the area to be worked on is great enough to cut a bar of steel within a

relatively short time. As long as the point of contact is a small narrow one, it will yield rapidly.

Trumming threads from the finest strands to the thickness of ropes may be used. A fine abrasive cloth strung in a jeweler's frame also makes a fine finishing tool.

A SYNOPSIS OF SURFACE EFFECTS

Mirror finish — total reflection of light, no color

Color finish — metal color dominant over reflection

Butler finish — the finest circular streaks in evidence

Fine matte — the finest surface without reflection

Cut finish — the finest grinding marks, wheel sweeps in
 evidence

Matte — visibly granular, scratch-free surface

Scrubbed matte — scratched fine nonshine

Fine planish — shining minute facets

Sand, dust blasted — apparent but not true porosity

Fine etch — pebbly, or crystalline, matte surface

Finest file marks — very short cuts resulting from thorough
 crossfiling, #6 file marks

Finest grit abrasive — #600 abrasive

Cast surfaces — the finest of surfaces

Florentine by burrs and burens — engravers, burrs of
 various kinds

Chased surface — fine strike marks from chasing punches

Chased texture — fine strike marks from textured chasing
 tool

Engraved texture — singular lines from engravers of various
 kinds

Chiselled — chisels used in cutting the surface

Cross- or ball-peened — surface marks left by these tools

Roll-printed texture — material rolled between two sheets
 in a rolling mill

Fused texture — partially melted and fused particles

Reticulated texture — reticulation on cuprous or silver-
 bearing metals

Flame perforated texture — high heat treatment on cu-
 prous nickel-bearing metals

8

Shell Structures

Every work of art begins as an idea in the mind of its creator. Once an artist has formed a conception of the work, it is then necessary to select a medium for its expression, and finally bring the work to fruition by application of the appropriate techniques. In reality, of course, the creative process does not always divide into such neatly defined stages. Frequently, the artist's original conception will include form, medium, and technique in a single inspired stroke. But for purposes of discussion, it is easiest to treat each of these aspects of the creative process separately.

In this chapter, we shall discuss some of the more advanced phases of metalsmithing, and we shall follow just such a division of the creative process. First, we shall discuss the aesthetic aspects of the subject, which deal with questions of form and structure, and the crucial role they play in the creative process. Second, we shall discuss the practical aspects, which deal with questions concerning the potentials and limitations of the materials and tools available, and the implications these have in the choice of a medium. Third, we shall discuss the technical aspects, which deal with questions of technique and the application of tools to specific problems arising in the actual manufacture of the work itself. Finally, we shall close with some specific examples of shell forms beyond the domical, cylindrical and cubical already discussed, and indicate their possibilities for use in more complex structures.

AESTHETIC CONSIDERATIONS

The objects with which people surround themselves serve as reflections of their personalities and the times in which they live. For some, simple objects may serve this purpose well, but for others, more complex forms of expression would be better suited, forms commensurate with their intellectual growth and development.

In metalsmithing, such levels of complexity demand that artists look beyond the formal shells previously discussed to the informal shells, forms that are inherently freer. In the past, form has been dictated primarily by function, a phenomenon reflected in the vocabulary that has been in general use among metalsmiths. If greater creative horizons are to be opened to the metalsmith, the use of generic, form-oriented vocabulary must be instituted in place of the more traditional, function-oriented terminology. The generic language is neutral, serving merely as an instrument of communication. It does not predetermine the use a form will have, thereby leaving the artist free to explore form for its own sake.

It is important to note that in addition to form, structure plays a critical role in the aesthetic satisfaction afforded by a work of art. For example, in the case of two apparently identical objects, one may be structurally poor and the other structurally sound. The structural excellence results from a more judicious choice of materials and better application of available technology. This in turn affects the aesthetic appeal of the work, its very concinnity asserting itself as an aesthetic value.

In their efforts to create new works, metalsmiths must bear these ideas in mind if they are to answer the need for more complex and structurally sound objects that reflect the spirit of our times.

The Form/Surface Dichotomy

Every piece of metalwork contains two separate features, namely, the underlying form with its structure, and the outward finish, or surface treatment. Thus, there is a form/

surface duality to be considered in every three-dimensional piece of work. Of the two, it is wiser to consider form as the more important, since, although the initial impact of the finish may be quite striking, with the passage of time the luster will dim, and the true, underlying nature of the work will be revealed.

Although it is true that an elaborate surface treatment can effect a marked improvement in a piece, the question still remains whether it is adding to the value of the piece, or merely covering up its structural defects. Since metalsmiths control both the form and the surface treatment, they should pay careful attention to both. A consciousness of form should be nurtured from the very beginning of their training. When a form has been embodied in a suitable structure, and the properties of the metal chosen as the medium of expression have been taken carefully into consideration, the resulting work will not only be sound, but also beautiful.

PRACTICAL CONSIDERATIONS

Once the form and structure of a piece have been decided on, it is necessary to determine the proper medium. It should be noted at this point that the techniques described herein are very much dependent on human dexterity, and apply only when the hands play the major role in manufacture, the sequences of operations described here being predicated on the skill of the craftsman, and not on that of machinery. Thus the scale of a piece is restricted to that which can be managed by a single human being. The methods illustrated here can be used to make one-of-a-kind objects; efforts to mechanize the processes would surely rob the results of their uniqueness, and destroy the spontaneity so necessary for vitality in a work of art.

Many forms can easily be made from solid materials (casting), but if these forms are to be handled by human beings, yet another factor in addition to size comes into play, namely, weight. A piece that outwardly appears light and fragile, but is in reality heavy and monolithic, will soon be discovered by an observer.

Overly large pieces can be so heavy that it is difficult to wear them or handle them unless they are structurally hollow. To avoid making a piece that is too heavy, it is best to utilize the weaker and lighter parts of the structure by increasing their strength. To do this, however, one must thoroughly understand the structural strength of metals and what happens to them when they are worked into various forms.

The medium chosen to express the idea should not be forced into roles for which it is structurally unsuited, nor used for purposes that demand less of it than it can actually give. This, fundamentally, involves a certain "honesty" towards the medium. It is this "honesty" that helps us determine the proper roles for new, artificial materials, which always present difficulties in the attempts to find an authentic place for them without infringing on the roles belonging properly to other media. It is absolutely necessary in this respect that the creative artist achieve a rapport with the materials available.

In understanding the potentials and limitations of metal, it is necessary to bear in mind that metal is a plastic medium. Although, from a microscopic standpoint, metal possesses a crystalline structure, its state at room temperatures is basically plastic. The plasticity available in metal is more difficult to take advantage of than that in the medium generally known as plastic, but nevertheless, plasticity is the true nature and characteristic of metal.

Metal's capacity to act much like other materials is testimony of its protean nature. Metal has a place of its own and its own proper roles in relation to other materials. Wood, for example, serves much better than metal in some places, yet metal can be spun into fibers and even made into the same forms as wood. It is best, however, not to ignore the natural properties of materials when considering them as media of expression for artistic ideas.

TECHNICAL CONSIDERATIONS

Books such as this have a tendency to offer *the* way of doing things when they prescribe a technique for a given

operation. The reader should be reminded, however, that there must be at least *one* way of doing things in the first place if any way is to be prescribed at all, and it is wise to bear in mind that if there is a known and tested way of doing something, then that way is to be preferred to trial and error. The statement that "Any method that works is the right one" is no more than a simple-minded sanction of inefficiency.

Some of the abuses of certain tools in metalsmithing have been pointed out in prevoius chapters. Such abuses are all too frequent in metal studios, particularly in the use of hammers and stakes, and in the buffing and polishing operations. The well-planned construction process takes into account the efficiency of the tools used, the time and energy expended, the relative expense, the relative accuracy, etc. Obviously, in weighing all these considerations, some sacrifices have to be made, but the careful artisan will see that these sacrifices do not impair the artistic value of the work to any significant degree.

Many of the work processes illustrated here will be reiterations of those previously explained. The point is to show the applicability of the techniques to more than one form. The basic operations, and the sequence in which they are performed, will not be precisely identical to those already discussed, as there will be small differences in the order of doing things as well as in the uses of certain tools. It is hoped that the discussion will yield more than just one way of doing things, and that it will suggest a creative process within the technical performance.

SHELLS, FORMS, SHAPES, AND SHELL STRUCTURES

Before we proceed, we shall clarify the use of the terms *form*, *shape*, and *shell*.

The word *form* will be used to denote a three-dimensional object, regardless of its nature. As long as the object is demarcated by tangible material, whether solid or hollow, the object will be referred to as *form*.

The word *shape* denotes a flat, silhouettal image. It might be bent, but as long as the shape can be unfolded to its original flat, two-dimensional state, it will be referred to as *shape*.

The word *shell* means the outer skin of any form. The shell form is never solid. It begins as a flat shape, but through the shell-structuring technique, it evolves into a three-dimensional object and finally into a hollow structure; thus the name shell structure.

HAMMERS AND MALLETS

The workhead of a hammer is called the 'peen', regardless of its form or the use for which it is intended. 'Cross-peen' means that the peen is crosswise to the handle. 'Ball-been' or 'sphero-peen' take their names from the spheroidal form of the peen. Similarly, 'flat-peen', 'crescent-peen', 'spheno-peen', 'minisco-peen', and 'tripoint flat' all take their names from the particular form of workhead they describe.

When assembling a collection of hammers and mallets for the workshop, it is important to fulfill the following requirements:

1. A wide range of forms
2. A good gradation of forms from one extreme to the other in all form categories
3. A range of weights
4. A range of sizes

The great variety of hammers is frequently a source of confusion as to their proper use and functions. Unfortunately, no simple rules apply here. It is helpful, however, to arrange the stock of hammers initially so that each hammer-form belongs to a group of hammers. The illustration provides a few such examples. The top row represents hammers belonging to the cross-peen category. Some of these are forming hammers, some raising, some fluting or crimping. All of them can be given their generic names according to their forms. Basically, the type of function determines the grouping.

66

HAMMER SAMPLINGS

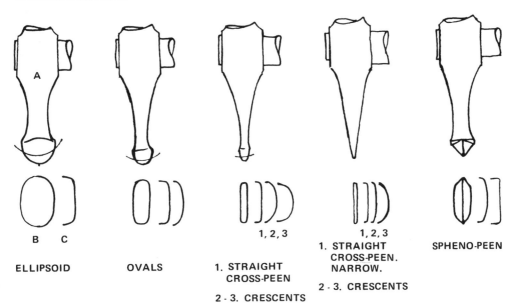

| ELLIPSOID | OVALS | 1. STRAIGHT CROSS-PEEN 2 - 3. CRESCENTS | 1. STRAIGHT CROSS-PEEN. NARROW. 2 - 3. CRESCENTS | SPHENO-PEEN |

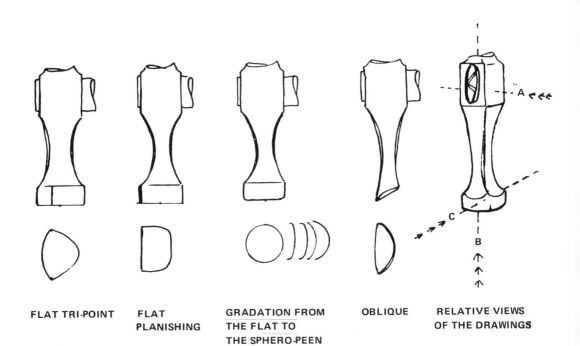

FLAT TRI-POINT FLAT PLANISHING GRADATION FROM THE FLAT TO THE SPHERO-PEEN OBLIQUE RELATIVE VIEWS OF THE DRAWINGS

The second row illustrates some planishing hammers, although it is by no means indicative of a complete sampling. The middle hammer, essentially a flat hammer, has gradations running all the way to the ball-peen forms. There are, in addition, a number of other planishing hammers belonging to the same general grouping.

The surfaces of the peens should be true and pitless, and the least important thing about hammers is whether they shine or not. Well-fitted and well-oriented oval or faceted handles are the best. Loose, crookedly mounted, or round handles do not work very well.

BEGINNING THE SHELL STRUCTURE

In order to take advantage of the plasticity of metal in a different way from raising, let us consider the total elastic potential afforded by the metal's plasticity. This potential comprises compressibility, bendability, stretchability, and joinability.

Furrowing a strip of sheet metal is one of the basic forming operations. It can be done over a groove in wood or plastic, either with a metal hammer on wood, or a wooden mallet on a metal stake.

The twist, another forming operation, involves complex sets of stretching and compression. The twist can be effected by oblique hammering. One-way oblique hammering effects one-way twist. Oblique hammering in the opposite direction produces the opposite twist.

Stretching and compression are the main operative actions involved in synclastic and anticlastic sinking. There are areas in both operations that must be so worked that stretching and compression take place. Understanding these operations and acquiring the skill to bring them forth in one's own work are the basis of successful shell structuring.

Furrowing involves a simple bending of the sheet stock. The twist
can be added to it. In this operation, the metal is left in a condition in
which it passes through one curved plane and one flat plane.

Synclastic sinking is an operation in which the sheet is sink-hammered
until its surface develops two distinct curvatures, each at right angles
to the other, and the convexity of each oriented in the same direction.
A twist may be hammered in for added dynamism.

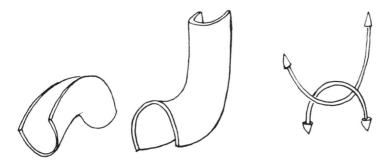

Anticlastic sinking is a sinking operation in which the sheet is ham-
mered into two distinct curvatures, each at right angles to the other,
and the convexities oriented in opposite directions. As with synclastic
sinking, a twist may be hammered in.

FORMAL SHELLS BREAK INTO INFORMAL SHELLS

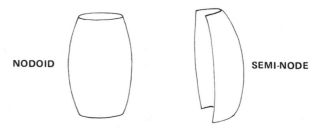

NODOID

SEMI-NODE

The illustration shows the nodoid and semi-node. This is a rotation surface and hence a prescribable form. The semi-node is, however, a freer form and less predictable in its construction. It breaks away from the rotation format. It is a synclast.

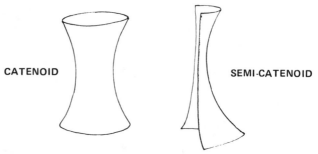

CATENOID

SEMI-CATENOID

This figure shows the catenoid and semi-catenoid. The catenoid is a rotation surface. In a stricter form, it could even be a ruled surface. The semi-catenoid is a strong form because it is basically anticlastic.

SHELL STRUCTURES — LEVELS OF COMPLEXITY

Structures made of sheet metal can be classified according to their degree of transformation from the primal state to the three-dimensional, structured whole, as shown in the accompanying illustrations.

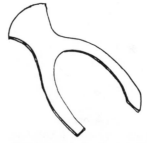

Cut-out, primal state. This state is limited to flat planes, monobends, twists, and prismoidal structures.

70

Mesomorphic state. In this state, the sheet metal is metastasized to the limits of its plastic qualities into a form that gives it strength. This is the state of half sheet, half structure.

Paramorphic state. To create a whole structure from a mesomorphic form, another form is joined to it (sometimes it can be made from the same sheet). The hollow structure becomes rigid and extremely strong.

Structured whole. The form can now be used to realize new forms by cutting it up. The structural strength is maintained by mating each piece with new solidifying parts.

WORK PROCESSES

Synclastic Sinking

The sheet of metal used may have any dimensions, but should not be too thick or too thin. The sheet illustrated is 0.8 mm thick.

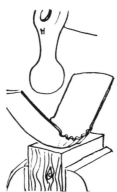

The sinking illustrated here is done on an endgrain wooden block. There is no need to carve a deep hole on the wood surface. A depression slightly larger than the hammerhead is enough.

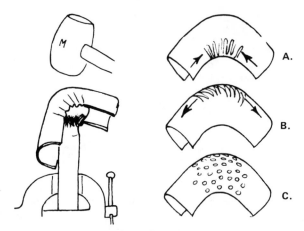

Malleting out the crimp-flutes starting from the roots of the crimps helps to compress this part. A little tension against the two ends helps to maintain the angle of the bend, otherwise it tends to straighten out. Use a wooden mallet on a metal stake, and vice versa.

- A. This part of the bend is compressed, and the metal tends to thicken slightly.
- B. This part of the metal is stretched and tends to thin.
- C. Planishing tends to stretch the surface all over.

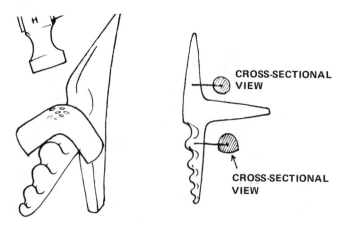

The planishing phase of the operation is done with a metal hammer on a metal stake, as shown at left. Here the form has already been realized, and only the smoothing remains to be done. The metal stake shown at right, is 45 cm long and has progressively larger anticlastic and synclastic forms on which to work. The other end is a round taper.

Anticlastic Sinking

A sheet of metal (brass, copper, bronze, silver, nickel-silver, gold, tin, pewter, etc.) is used. The sheet illustrated in the metal measures 0.8 mm thick, 30 mm wide, and 150 mm long.

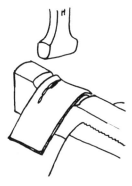

First the sheet is bent, and then carefully hammered in a wood groove starting close to the edge. The idea is to get a small amount of material to bend at a right angle to the rest of the sheet. This tends to maintain the axial radius of the bend.

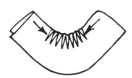

A. THIS PORTION OF THE METAL IS COMPRESSED.

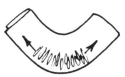

B. THIS PORTION OF THE METAL IS STRETCHED.

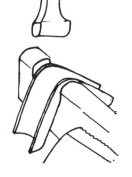

C. THIS ILLUSTRATES THE RESULTS OF PLANISHING.

Since the center part has to be compressed, the hammer blows must land just a little on the other side of the stake contact point, opposite the hand steadying the work. This prepares the metal for bending.

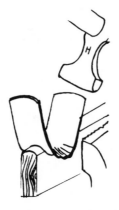
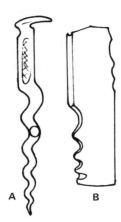

A B

Here is another way of achieving the same results, one that works better for larger and wider pieces. The stretching is done on the edge. Ideally, both of the illustrated methods should be used on the same workpiece.

A is a steel stake 3 cm in diameter and 60 cm long. B is either hardwood or else a hard plastic such as nylon.

Anticlastic and Synclastic Sinking Combined With Raising

The flat sheet pattern in Figure A is considerably simpler than the final form. The skill for exact measurements of a predetermined finished size will come with experience.

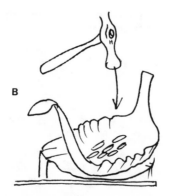
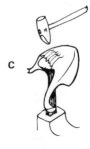

A B C

The soft sheet is sink-formed on an endgrain wood stump, as shown in Figure B. The characteristic crimps may be deliberately hammered in place, or else allowed to develop as the work progresses. The regular raising technique is used across the crimps, as shown in Figure C. A wooden cross-peen mallet is used to drive the crimps down starting from the roots of the crimps. This can be repeated as many times as is necessary to gain the desired depth.

In Figure D, the deck, or second shell, is formed. It is planished and fitted with the necessary lid reinforcements before joining. The two shells may be tack-soldered to ensure a springless fit. Sometimes it is best to tie the shells together and anneal the deck, only to release the springiness. Then the piece is cleaned and soldered.

In Figure E, the deck is fitted and tied, and is now ready for soldering. The second shell is left a bit larger than the first one for better fitting and soldering.

Final trimming, shown in Figure F, is done after all soldering is performed. The piece is now a sound paramorphic structure.

INTERCHANGEABILITY OF COMPOUND CURVES

A piece is said to have a compound curve when it is composed of two or more curves that cross each other at approximately right angles.

In the mesomorphic state, curves A and B are interchangeable. If one is increased, the other is decreased.

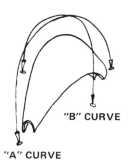

As a result of hammering, a curvature, as in the adjacent figure, is developed. This convolution can be changed by depressing the piece endwise, as illustrated here. This will result in an increase in the corresponding dimension, at approximately a right angle to the direction of the depression.

This illustrates the result when the forces are applied opposite to those illustrated in the preceding figure.

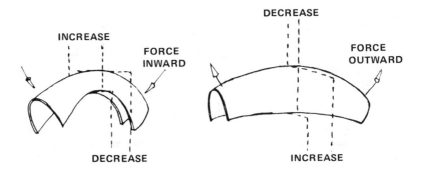

The phenomenon illustrated in the preceding figures can be applied in choosing the planishing stakes and hammers. A difficult area can temporily be exchanged for an easier one to work with, and after the planishing is completed, it can be returned to its original form.

SHELL STRUCTURES — CATEGORIES

MONO-SHELL

In their basic state, shell structures are quite simple. They are divided into categories for the sake of simplification in teaching and discussion. It is this area of metalsmithing in which a vocabulary is largely deficient. Because of this, we shall suggest generic terms whenever forms are discussed.

The word *shell* is the best term for describing a three-dimensional form made of uniformly thick material. Its other meanings, such as its application to certain shellfish, are purely coincidental for our purposes. Such other meanings should not interfere with the application of the word to the subject matter at hand.

The mono-shell is a single piece of sheet metal from which a structure or partial structure is made. Its form potentiality is less than that of the more complex shells, but its beautiful simplicity can excite any craftsman. This simple form, like the spiculum, will help conserve material and render the finished product light and strong.

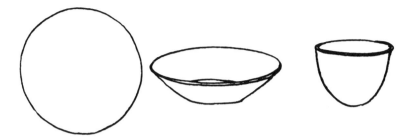

A domical form, serving as a cup for whatever purpose, is an example of a mono-shell, as it is made from a single piece of material of uniform thickness.

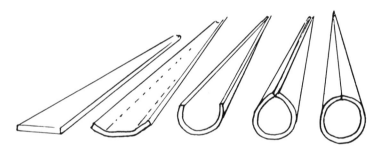

A spiculum is an excellent example of a mono-shell with almost total structure.

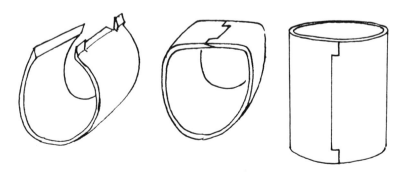

A lap-jointed cylindrical form is a mono-shell, if it is left in that state, but if another sheet is added to it, it becomes something else.

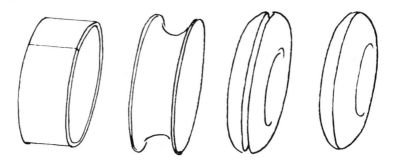

This is a mono-shell torus, which can be hammered out relatively easily.

THE BI-SHELL

The bi-shell as the name implies, is a structure made from two shells. Its potential for complex forms is much greater than that of the mono-shell. Its construction is more involved, although the simplest bi-shells present few problems. The combination of two shells, which are joined by soldering, gives the total structure great versatility. Both shells can be shaped into their respective, individual forms as long as there is a common intersection line (the seam) along which the two shells meet. The soldering operation will leave the piece soft, except when the hollow structure is filled with some resilient material like pitch and chased after soldering. This will render the piece somewhat work-hardened.

The form potential of the bi-shell gives the metalsmith a great amount of latitude, from making the simplest forms to those which have a high degree of complexity. The technique has been used in industry for a long time. It is now up to craftsmen to take up this fruitful form and utilize it fully.

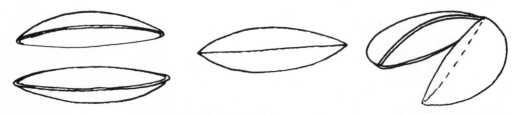

A typical bi-shell is made from two sunken disks that are soldered together. If such a structure is halved and another sheet soldered to cover the opening, the resulting structure will be a tri-shell.

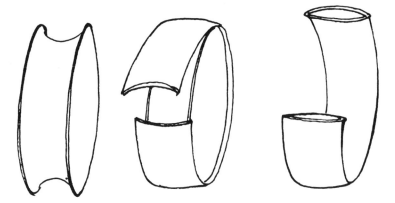

This is a very simple anticlastic and synclastic combination that is often used for making bracelets.

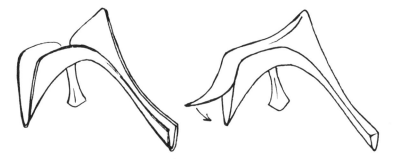

The bifurcated form shown here is a bit more complicated example of the bi-shell. The upper shell, called the deck, is the simpler of the two. The lower shell is usually made first, as complete as possible. The deck is then fitted and soldered on.

TRI-SHELLS AND MULTI-SHELLS

The starting forms are simple, and with few exceptions the forming is done by the sinking method, sometimes to a lesser, sometimes to a greater state. The fitting and mating of the pieces for soldering can often take longer than the forming of the components. As can be seen in the accompanying illustrations, a relatively simple form can undergo very complex development even under a single type of developmental technique.

An effort is made on these pages to present the essence of the ideas without suggesting any designs. It should be pointed out that the most complex transmutations shown are deliberate exaggerations, and not reflections of any style or taste.

Mono-shells, bi-shells, tri-shells, or multi-shells offer wide varieties of potential for the propagation of new forms if one dares to go beyond the obvious. The forms can also be cut in various ways after they have been put together, thus offering yet further possibilities for development.

There are basically four planes along which to develop form, namely the two vertical planes, and the two horizontal ones. These four tend to dominate during the design stages, but as the shells themselves are still in a relatively flexible state before joining, the diagonal planes also present themselves as strong possibilities in the design. The final joining of the individual shells stabilizes the whole form in a unified body.

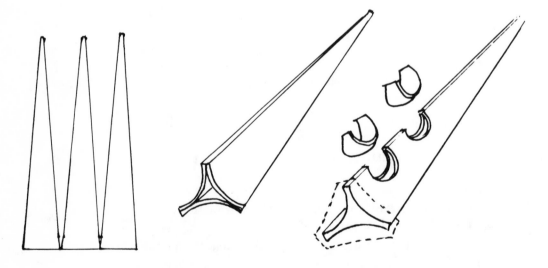

The xiphoid, made of three parts, is a good example of the tri-shell.

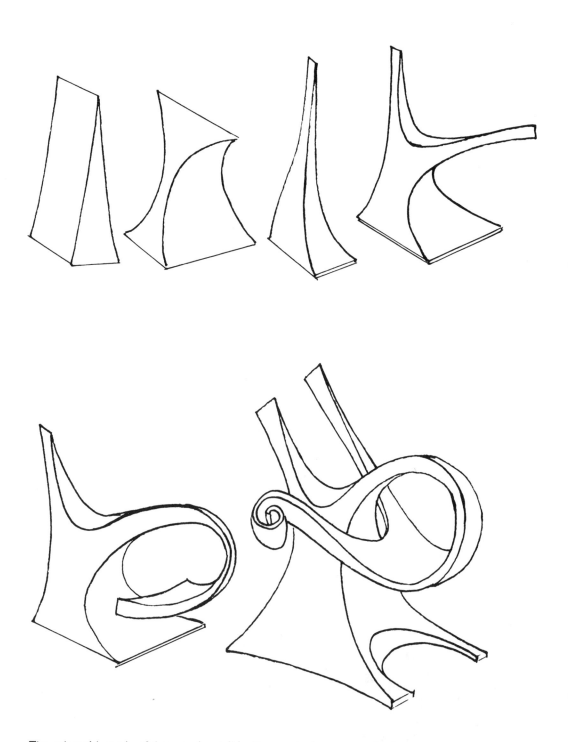

The sphenoid, made of four, and possibly five, parts, is an example of a multi-shell. Its possibilities grow as the various planes are given more complex roles to play.

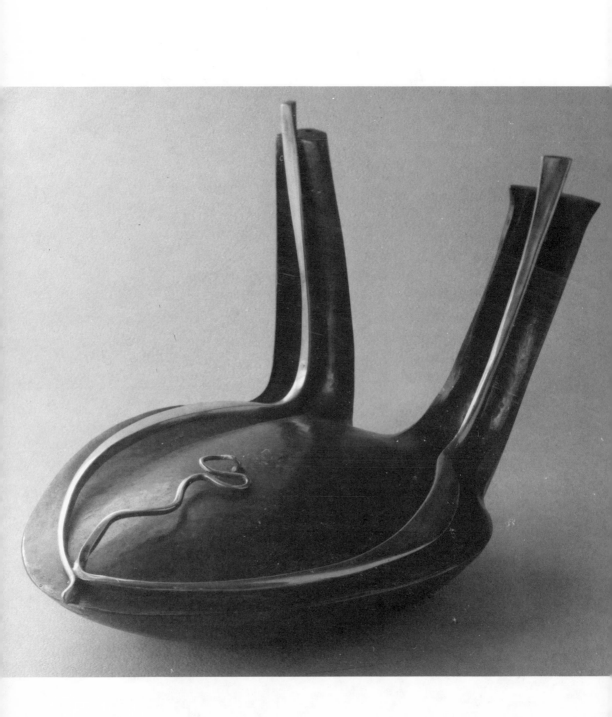

9

The Spout

CONSTRUCTION OF THE SPOUT USING THE BI-SHELL STRUCTURE

The pattern for the first shell can be determined from the intended size. Since the area in which most of the sinking takes place can be calculated roughly by resorting to the rules on sinking, cutting the pattern out presents hardly any difficulty. It is wise to save old proven patterns for future reference to gain the benefits of experience.

The pattern for the second shell, or deck, is also easy to determine. After the first shell has been hammered out, simply place a piece of paper against its edges, and draw the outline, allowing extra material for the more curved places and a little extra for the overhang.

The furrowing does not stretch the metal at all, and there is very little stretching in the widest part. The final form and contours of the vessel must be taken into consideration in drawing the pattern for the spout. The spout should be mounted neither too close nor too far from the vessel wall.

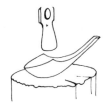

The endgrain of any soft wood, such as alder, poplar, cedar, redwood, or even soft maple, provides a good work surface for sinking the main parts of the spout. It is best not to overdo the sinking, and proper regard should be given to the thickness of the metal. The synclastic part of the sinking is best done with a soft, roundish (but not entirely round) hammer.

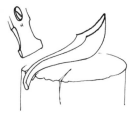

The same kinds of woods can be used as work surfaces to complete the anticlastic sinking and the furrowing. For this phase of the work, it is necessary to form a groove in the wood. A stump has been illustrated here for clarity. There is a possibility of hammering the metal into a twist. This can be avoided by delivering the hammer blows alternately from both sides of the work. A twist can be eliminated only by reversing the actions that bring it about.

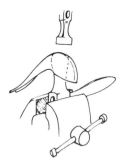

Once the forming has been done, the planishing phase begins. The same hammers may be used, but now they are used only as stakes. At this time, the form's trueness and exactness of line are checked. The fit of the two shells must be secured, and the solder line, or intersection line, must fall in the right place. If there is surplus material, it is snipped, sawed, or filed away. In mating the two forms, it is a good idea to tie them together with binding wire and anneal the deck only. This may be done repeatedly if necessary.

As shown here, the strong anticlastic part of the deck may be worked from the outside or from the inside. **Note:** if the deck is worked from the inside, a wood stake and metal hammer are used. If the deck is worked from the outside, a wooden mallet and an iron stake are used. It is best to work the shell from both sides alternately to avoid twisting.

The synclastic part of the deck is formed the same way as the main shell, on wood with a metal hammer.

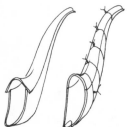

There are basically two approaches to joining the decking. One is the butt joint (right), the other, the tee joint. The butt-jointed seam will leave no intersection angle on the final form, whereas the tee-jointed one will take advantage of the joint in its design. The tee joint is simpler to make.

FACTORS AFFECTING SPOUT FUNCTION

Taper of the Spout Outlet — Departure Velocity and Behavior of the Liquid Column

A B C

The spout outlet marked A narrows and then widens again, which causes the liquid column to speed up and then slow down, causing the liquid to splatter.

The spout outlet marked B is underdeveloped, and as a result, the departure velocity of the liquid is too great, causing it to hit the receiver cup with a splash.

The spout outlet marked C is properly constructed, its last wetted walls being formed in such a way as not to disturb the liquid column in its natural flow. In a closed spout, this is simpler than in an open spout.

Sharpness of the Lip

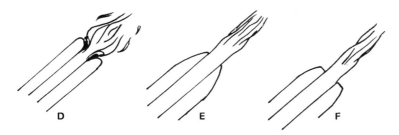

D E F

In the spout marked D, the wetted inside surface dictates the flow of the liquid column at the last moment, causing the column to break.

In the spout marked E, the tip is sharp, and an excellent outflow is created. The tip itself, however, is vulnerable to breakage.

The spout marked F shows an ideal compromise in the sharpness of the lip.

Height of the Spout above the Liquid Level and the Lid

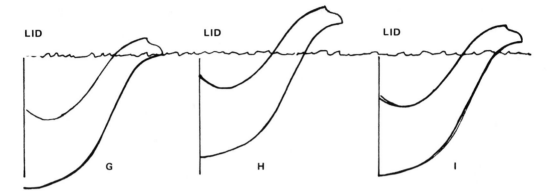

In the spout marked G, the shortness of the spout taxes the effective volume of the vessel, resulting in premature pouring.

The spout marked H is too tall. The liquid will flow out of the lid first when the vessel is full.

In the spout marked I, the spout outlet is just about level with, or a little below, the lid line. This results in correct functioning of the spout.

The Slant of the Outlet when the Vessel is in a Stable Position

In the spout marked J, the last few millimeters of the wetted surface of the outlet are tilted away from the body of the vessel, causing the remaining liquid to drip.

In the spout marked K, the last wetted surface of the outlet is tilted towards the body of the vessel, causing the liquid to run on the outside when the vessel is full during slow pouring.

The spout marked L is a well-pouring, dripless spout. The last wetted surface of the outlet is horizontal, and at the slightest motion to pour it is tilted outwards, as it should be.

The size of the spout is also very important. For instance, a water pitcher should have a large, generous spout, whereas for pouring only small quantities of liquid, a smaller spout is appropriate.

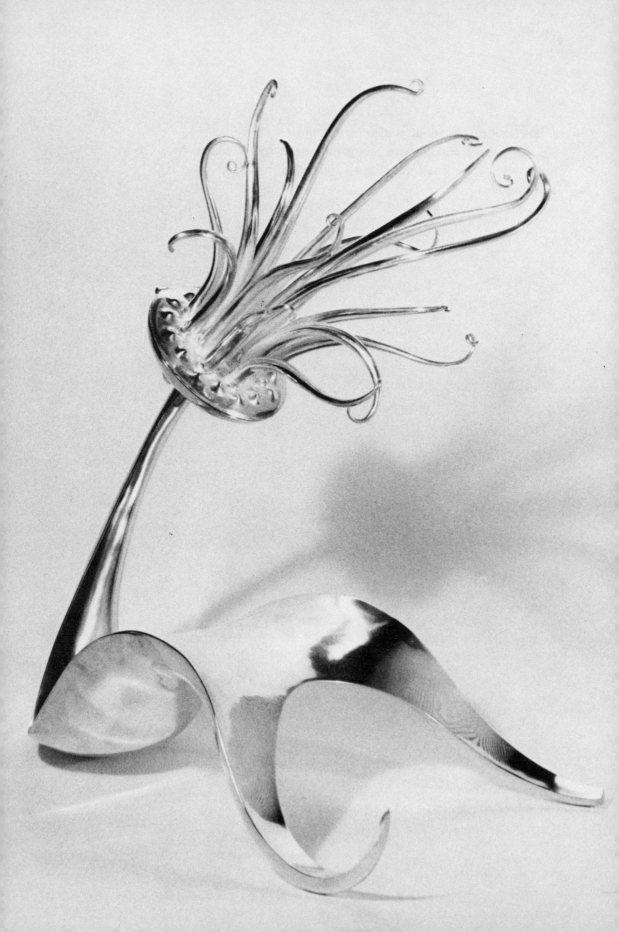

10

Work Processes for Various Forms

THE INFUNDIBULUM

From a circular disk, sink or raise a domical form high enough for the need. Begin collapsing the edge inward, using a soft cross-peen hammer on a mushroom stake.

Use smaller and smaller mushroom stakes to reduce the skin until the desired shape is reached. Punch a hole through the top and work it larger by means of a tapered mandrel.

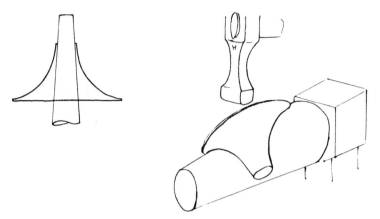

Do the straightening and firming with the tapered mandrel. It is best to do the final planishing from the inside, using a soft cross-peen or a slightly belled round hammer.

Development of the Scutate or Peltate from the Surface of a Clean Sheet Stock

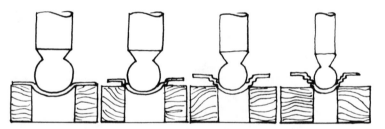

Method One uses a series of successively smaller punches and holes in wood to gather the material for the maximum stretch. The hammer-driven punch tends to thin the metal at the point of shear, thus allowing the gradual stretch of the wall.

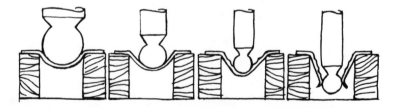

Method Two uses the same size hole, thus omitting the emphasis on gradation. A different kind of gradation, however, is gained by using successively smaller punches.

Finally, in both methods, the bottom is punctured and filed clean, and then the hammer work is done on various stakes.

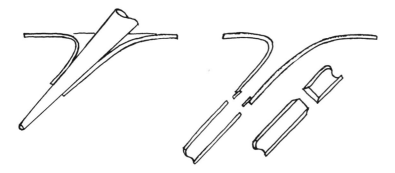

Acentering or slanting is possible with a tapered mandrel. There is some stretching needed on the slope side to allow the slant, and likewise, some corresponding compression needed on the tight side. Extensions to the stem of the infundibulum may be added in various ways.

THE HYPERBOLIC PARABOLOID

The hyperbolic paraboloid is actually the formalized version of the anticlastic surface. Its precise definition is of little concern to the metalsmith because the material is in constant flux and should not be submitted to exact measurements in such a way as to restrict the creativity involved in the art.

The hyperbolic paraboloid is one of the few forms that can produce a self-bracing structure. This kind of anticlastic surface becomes very strong by itself, its strength being many times that of the initial sheet.

Many variations of this form can be made with hammers and mallets. This offers exciting possibilities for the metalsmith, who can take advantage of the form without the trouble of calculating every measurement on it. Indeed, the great flexibility and responsiveness of metal is one of the strongest points in its favor as a medium of artistic expression, offering the artist direct contact, with only the handtools acting as extensions of the hands, so that the spontaneity of the creative moment is sustained throughout the work.

The starting sheet is a square sheet of metal.

Stretching is done on the opposite straight sides.

The sheet is turned over and stretched on the remaining two sides.

This figure shows the resultant form.

This figure shows the result of extending the stretching.

This figure shows the theoretical result of closing the extended ends.

In the illustrations below, the stretching is done on the corners. The results are somewhat different, but as a structure, the resulting form is quite strong and useable.

FROM THE MENISCIFORM TO THE CRESCENT, OR BICORNATE

The flat pattern is more open than the finished form because all the planes are slanted.

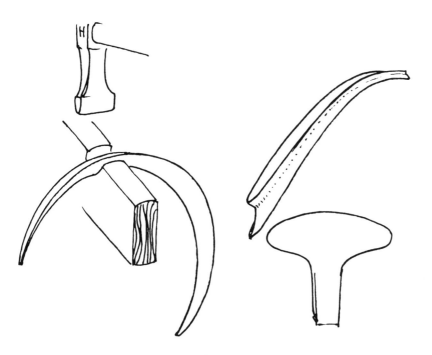

The three-dimensional mesomorphic form is hammered on a piece of wood and then planished and, perhaps, fitted on a person.

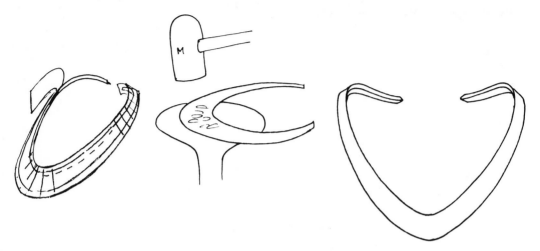

A paper pattern is developed from the edges of the first shell. After the metal has been cut according to the pattern, a slight concavity is malleted into it. This is the stage for contemplating the many different possible treatments on the second shell. Malleting is done only to form the deck enough to complete the structure.

THE SPICULUM, OR ACICULAR FORM

Preparing the Sheet Blank for the Double-Ended Spiculum

The blank is cut from sheet stock and may be of any size, but the optimum proportions of the thickness, width, and length, are important enough to note. These proportions assume even greater importance if the spiculum is to be bent into a sinusoidal form.

The maximum thickness to width ratio is 1:50. The minimum length should be nine times the width. The example given here measures 0.6 mm thick, 30 mm wide, and 270 mm long. These roughly optimal ratios apply to double ended spicula.

The reason for requiring a certain minimum length is that if the spiculum is too short, there is no leverage for bending it. Of course, the spiculum can be as long as one desires beyond this minimum length. It should be noted that different metals bend at different rates. It is a good idea to leave the ends of the blank slightly truncated to help in the forming process.

The grade-rolling is not always necessary, but it is best to do it when a well-made spiculum is desired. Since the taper-

ing of the blank upsets the optimal width to thickness ratio, it is best to reconstitute them. The thinning is done with a rolling mill in short grades or steps. The steps are then planished into a smooth, even gradation. It is invariably best to do the grade-rolling on the raw material stock before cutting the blank out.

Forming the Spiculum

Furrowing. All forming is done over a groove in an endgrain wood, or on a special plastic stake. A soft-edged cross-peen should be used. Begin the first row of hammer blows close to the edge. It is best to do this part now, while it is accessible.

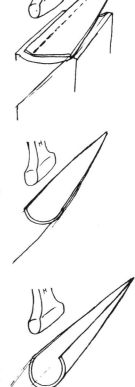

The woodblock has been omitted from the illustrations for simplicity. It is important to maintain the straightness of the strip, as it will be easier to close. Use a straight, but soft-edged, cross-peen hammer. For the narrow ends, the size of the hammer may have to be changed. The idea is to advance the whole form at the same time.

Before the form closes, it is a good idea to mallet it over a steel mandrel. Then anneal, but do not pickle clean. File the edges only, leaving the rest firescaled. This will help during the soldering phase. The solder stays in the seam.

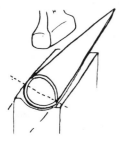

It is impossible to hammer the edges completely together. The following procedure, however, affords the best results. Leave the diameter directly in line with the seam, a bit longer than the rest, and hammer the edges as close as possible. The seam is still open at this point.

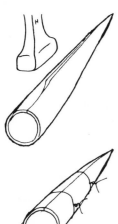

The ovality is now left directly under the hammer, which hits both edges at the same time, causing them to press against one another. This will normally make a sound seam, but if the diameter of the work is large, say over 7 mm, it is best to tie for soldering.

The spiculum is now ready for soldering. It is beneficial to do this in a vertical position for better solder flow. Later it is filed and polished smooth before bending.

Advantages of Bending the Spiculum

The important characteristics of the spiculum are that it is a very lightweight structure, uses much less material than solids, is relatively easy to make, is faster to make by hand than forging, and can easily incorporate various metals in the same piece.

Although the spiculum has been found to be useful as a straight, acicular (or needlelike) form, its potential is increased many times when its bendability is utilized.

The fundamental principal in bending tubing of any kind is that one surface must contract while the other expands. As a result, there is an area of relatively neutral action in between. Usually, the two neutral sides give way, and the two other opposed sides collapse against one another.

This knowledge can be used to advantage. One way to cope with the collapsability is to countercollapse the tube by hammering the sides so that they are more perpendicular to the direction of the bend (i.e., make the tube slightly oval). This permits the tube to be bent until its cross-section has become round again. Bending beyond this change, the

cross-section begins to form an oval at a right angle to the first one.

The ovality allows a proportionate amount of bending. Once it is exhausted, it can be hammered back in several times until finally the tube wall begins to turn squarish. If a sudden collapse occurs in some part, it can be cut out and patched. The seam is usually left on the neutral area so that it need not compress nor expand during bending.

The actual bending is done by hand, as the softness of human hands distributes the forces over a large area. There appears to be no mechanical device for bending the vari-thick spiculum that is quite as effective as human hands.

Once the spiculum is bent, it naturally becomes work-hardened, a fact that is important to remember when work-hardening is a necessary factor in the making of a given piece.

Bending the Spiculum

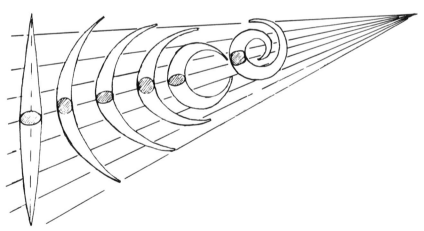

1. The basic structure is hammered oval for bending. The seam is on the upper plane.

2. The bending is completed to the point where the cross-section is round. Bending beyond this point would collapse the structure.

3. For further bending, the ovality is re-established.

4. The bending is continued.

5. The ovality is rehammered.

6. The cross-section is beginning to turn square.

If it is decided to bend the spiculum in more than one plane, the position of the seam is best forgotten. For very intricate bends, the spiculum may have to be annealed many times, so that very little bending can take place at any one time.

THE SPATHE

The spathe, ranging from the very wide to the very narrow, is an interesting and challenging form to work on. It is, of course, a bi-shell, although more shells can be used to complete the whole. In combination with other shells, the spathe lends itself to a wide variety of sound structures. In the actual construction of the spathe, it is often more advantageous to try forming the narrow projection from the spathe itself, rather than the other way around. Many variations are possible.

Work Processes in Making the Spathe

The starting flat pattern

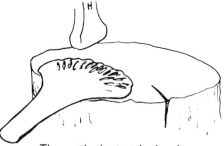

The spathe is stretched, using a hammer on wood.

The sides are stretched, using a mallet (not shown) on a metal stake.

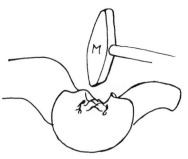

The center part is malleted into an anticlastic angle.

98

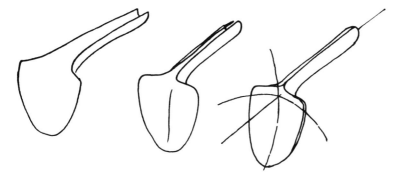

The open, partially closed, and totally closed stem (see spiculum forming)

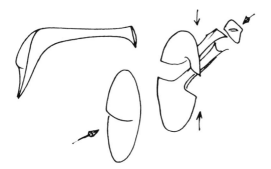

Side view and exploded view

The form is closed from all sides.

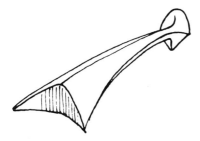

Variations of the spathe form. The work processes are the same.

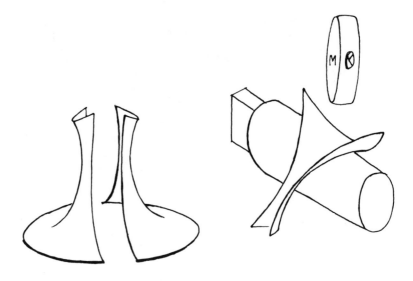

A pair of semi-catenoids

THE CHELOID, OR UNGULATE FORM

The starting flat pattern

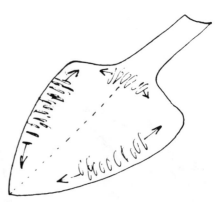

Strong stretching is done with a
cross-peen hammer on endgrain wood.

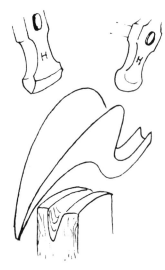

The form is folded in half and the stem is formed.

The deck pattern is traced using a piece of stiff paper. The deck is usually made a bit larger to facilitate tying and soldering.

The completed form, which may be used as is, or dissected to generate new forms

The two resulting forms, now having a flat base, can be used in an entirely new concept.

THE HELICOID

With Anticlastic Main Shell

The form is cross-peen malleted into a helicoidal state. The planishing may be done on the same stake, or on a straight, round taper.

The decking may be either synclastic or anticlastic. Whichever is chosen, the strength is greatly increased along the whole length of the body.

The synclastic sinking is done on an endgrain wood block. It is a good idea to sink the form a little deeper than intended. During the planishing phase, the curvature will adjust itself and tighten the helicoid.

The planishing may be done on the edge of a flat, round vertical stake, or else on some of the hammers that were used to sink the form in the first place. Understanding the idea of curvature exchange helps in the final trimming of the form. The decking pattern is developed by tracing on a piece of paper.

THE ALATE, OR PTERYGOID, FORM

The flat pattern may be cut almost at will. Seams may be made at the roots of long projections to save material. Compare with the material requirements of the finished form in the figure below.

The forming requires several different hammers and stakes. Some areas, requiring deeper sinking than others, are best started with heavier material. Calculations of the thickness required often become very complicated, and experience is usually the best guide. Wooden blocks are easy to make and modify. They are far better than solid iron stakes.

Paper patterns are developed from the edges of the first shell. Allowances for the extra spreads must be noted at this time, otherwise the deck shell will not have sufficient material for development into the form it must take.

The final fitting may sometimes present problems. A good practice is to fit the deck as closely as possible, tie it with a binding wire as snugly as feasible to the first shell, anneal it, then do a little more hammer fitting, and repeat the heat fitting. Once all the intersections are as close as the thickness of the sheet material, it is close enough to solder. The solder will not bridge a gap any wider than the thickness of the sheet.

THE FALCATE FORM

The starting flat pattern is approximately the total skin diameter of the first mesomorphic shell, allowing material for the breadth and the height.

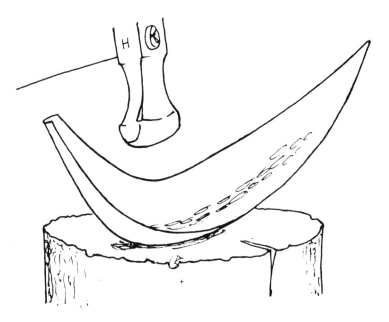

A soft cross-peen is used to gain the necessary depth for the form. The actual acumination of the ridge is done with a progressively narrowing series of soft cross-peen hammers. If the sharp hammer is used to soon, the metal will puncture before the depth is reached.

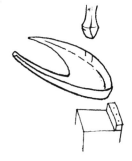

Note the relatively sharp hammer used in the acumination of the ridge. The sheet is stretched just enough to give the flat areas slight concavity.

Further straightening may be done on hardwood stakes. Planishing may be done from both sides of the form.

The decking should be either slightly concave or convex, but not absolutely flat. Mating the two shells should not present any problems because the underside is relatively even on one plane. If this is not the case, however, appropriate measures should be taken to compensate.

SHELL DIVISIONS IN PLANAR AND FACETAL STRUCTURES

Division of an Annular Bi-Shell

There are two basic approaches to the division of forms composed of two shells, the planar and the facetal. The former is characterized by shallow metastasis, such as that found in lentiforms. It is well suited to many applications, but can be costly and awkward to handle when applied to unsuitable forms. Generally it is best to weigh all the factors involved in the work processes: how the sheet metal will behave, what the yield is likely to be, and the difficulty of execution before deciding how the division should be made.

In Figure A, the planar division gives up the control of the roundness and makes the maintenance of accuracy more complicated.

In Figure B, the facetal division permits a great saving of material, control of the work, and ease of mating the two shell.

Division of Double Spiroid Bi-Shell

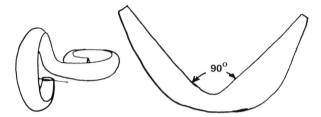

Facetal division of a double spiroid. Both of the shells required to make this form are, in their primal state, as simple as can be. The cut-out work is kept to a minimum. Furthermore, for the sake of economy, the ninety degree angle can be developed by seaming, thus saving even more sheet metal.

Planar division requires a considerable amount of work even in the primal state of the form. Hammering the form into the mesomorphic state is not only difficult, but requires a complex set of stakes. This is, however, the correct division for die-striking.

Bi-Shell Division of a Napiform

Problems can develop in the division of the bi-shell napiform both in planar as well as in facetal structure. The dimensional differences are small regardless of how the form is divided. In both cases, there must be sufficient metal thickness to yield the deep forms. Since it is almost impossible to develop the acuminated point from a single, unbroken sheet, the obvious advantages of sharp intersections with soldered seams dictate making the division in the manner shown in Figure A.

Note: It is best to avoid situations in which two dimensions are competing with one another. Accept one, and let it dominate. In Figure B, both shells would have to be sized accurately to a given circumference.

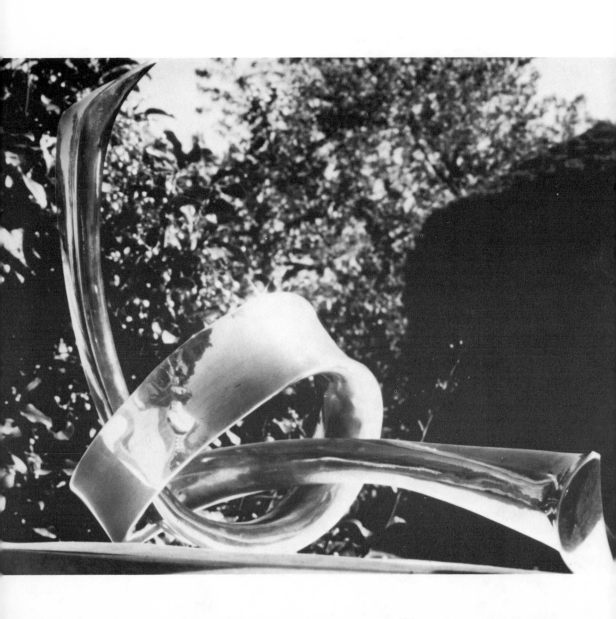

GLOSSARY

This illustrated glossary includes generic terminology for most of the forms developed in the text, as well as alternative terminology, and etymological origins where appropriate.

Acanthoid (Greek: *acanth-,* spine)
 also Echinate (Latin: *echinatus,* spiny)
 Muricate (Latin: *muricatus,* pointed)
 Spinous, spiny

Acicular (Latin: *acicula,* small pin)
 also Spicate (Latin: *spicatus,* shaped like heads of grain)
 Spiculate, spiculum (Latin: *spiculum,* stinger)

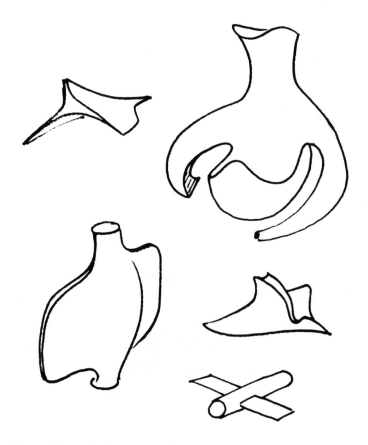

Alate, aliform (Latin: *ala,* wing)
also Ornithoid (Greek: *ornith-,* bird)
Pennate (Latin: *pennatus,* winged)
Pterygoid (Greek: *pteryx,* wing)

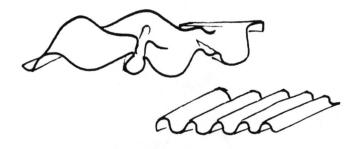

Ambagious (Latin: *ambagiosus,* roundabout)
also Convoluted (Latin: *convolutus,* sinuous, winding)
Corrugated (Latin: *corrugatus,* wrinkled)

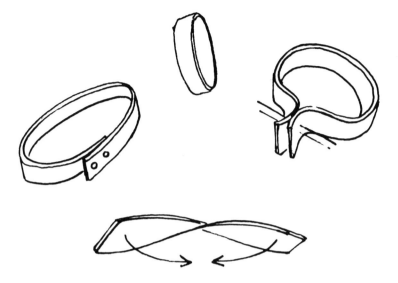

Annular (Latin: *annularis,* cyclic)
 also Baldric (Old English: *baudrick,* ornamented belt)
 Cincture (Latin: *cinctura,* girdle)
 Cingulum (Latin: *cingere,* to gird)
 Moebian curve, one-sided surface
 Penannular (Latin: *paene,* almost, + annular)

Ansate (Latin: *ansatus,* handle-shaped)

Anthropomorphic (Greek: *anthropos,* man)

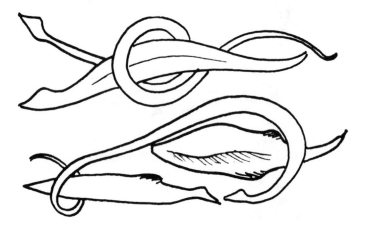

Aquatic forms
 Piscatory, piscine (Latin: *piscis,* fish)
 Selachian (Greek: *selachos,* shark)

Aquiline (Latin: *aquilinus,* curved or hooklike)
 also Acuminated (Latin: *acuminatus,* pointed)

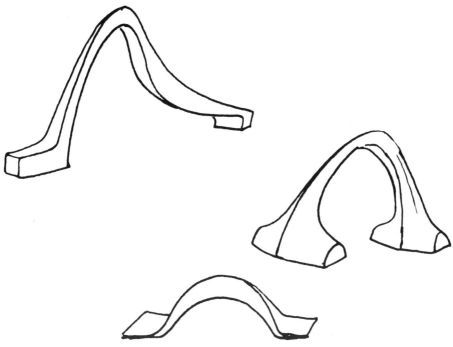

Arch
 also Archiform, arcual, arcuate (Latin: *arcus,* arch)

Aristate (Latin: *aristatus,* bristling with roughness)
 also Awn (Middle English: *awne,* bristle, barb)

Bi-corn (Latin: *bicornis,* two-horned)
 also Corniform (Latin: *cornus,* horn)

Bi-forked
 also Biflexed (Latin: *flexus,* bend)
 Bifurcate (Latin: *bifurcus,* separating into two parts)

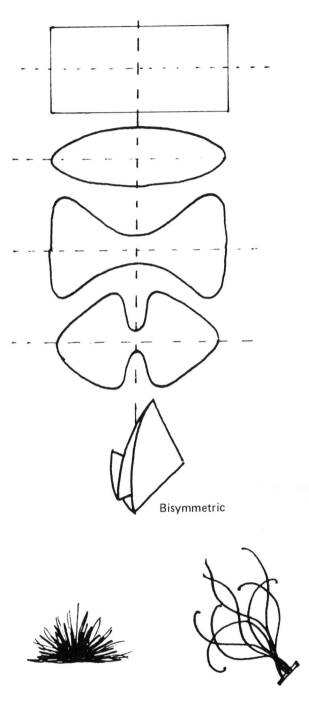

Bisymmetric

Byssoidal, byssus (Latin: *byssus,* tuft of long, tough filaments)
 also Filaments
 Tufts

Campaniform, campanular, campanulate (Latin: *campanula,* bell)

Cassideous (Latin: *cassis,* helmet)

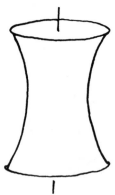

Catenoid (Latin: *catena,* chain, from the curve formed by a hanging chain)

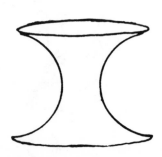 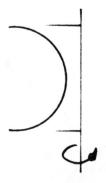

Rotation catenoid
Ruled catenoid

116

Anticlastic surface (Greek: *antiklastos,* curving in opposite
directions at a given point)

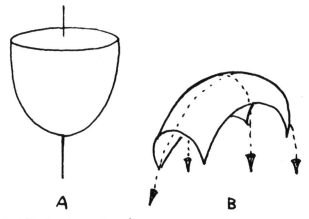

A B

Domical (Latin: *doma,* dome)
also Synclastic surface (Greek: *synklastos,* curving in the
same direction at all points)

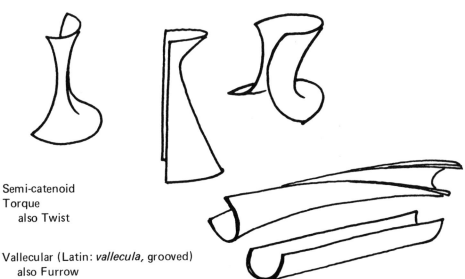

Semi-catenoid
Torque
also Twist

Vallecular (Latin: *vallecula,* grooved)
also Furrow

Chelate, cheliferous, cheloid (Latin: *chela,* claw)

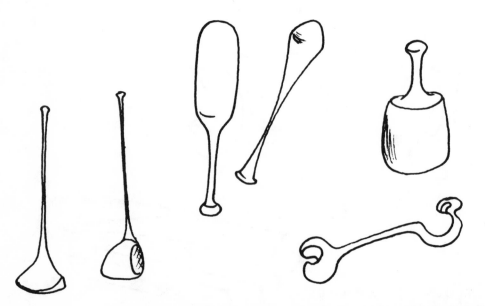

Cirroid, cirrose, cirrous (Latin: *cirrus,* curllike tuft)

Clavate, clavicornate, clavicular, claviform (Latin: *clavatus,* clublike)

Conchate, conchiform (Greek: *conch,* spiral shell)
also Cochlear (Latin: *cochlea,* snail)

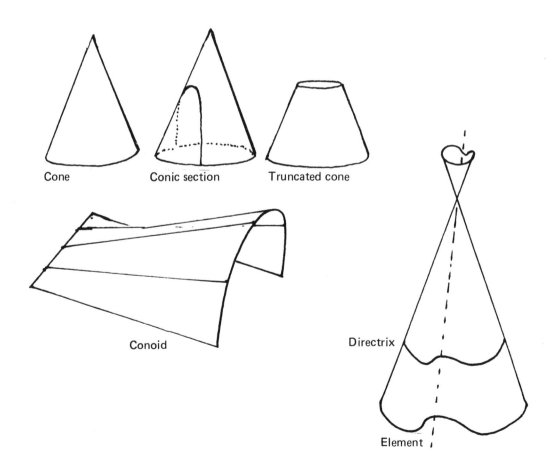

Cone Conic section Truncated cone

Conoid

Directrix

Element

Cordate, cordiform (Latin: *cors,* heart)
also Cardioid (Greek: *kardia,* heart)

Cube, cubic, cuboid

Cumuliform, cumulus (Latin: *cumulus,* heap)

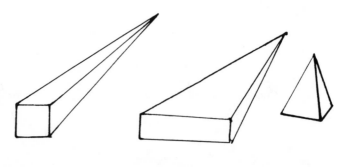

Cuneiform (Latin: *cuneus,* wedge)

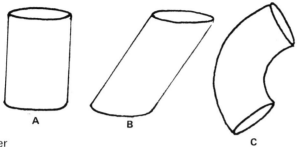

Cylinder
 also Columelliform (Latin: *columella,* column)
 A. Straight
 B. Oblique
 C. Bent

Cymbiform (Latin: *cymba,* boat)
 also Navicular, naviculate, naviculous,
 Naviform (Latin: *navis,* ship)
 Scaphe, scaphoid (Greek: *skaphe,* boat)

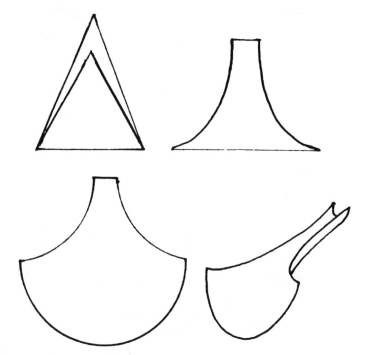

Delta, deltaic, deltoid (Greek: *delta,* Greek letter Δ)
Semiconical deltoid

Dendriform, dendritic, dendroid, dendron (Greek: *dendro-,* tree)

Dentiform, dentoid (Latin: *dens,* tooth)
also Odontoid (Greek: *odon,* tooth)

Disc, discoid, discus (Latin: *discus,* disc)

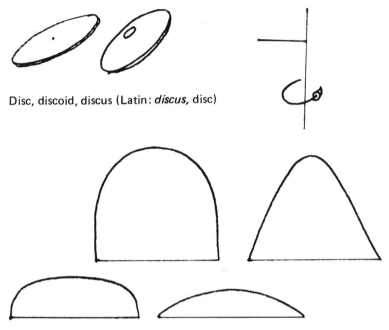

Domical (Latin: *doma,* dome)

Ensate, ensiform (Latin: *ensis,* sword)
also Gladiate (Latin: *gladius,* sword)

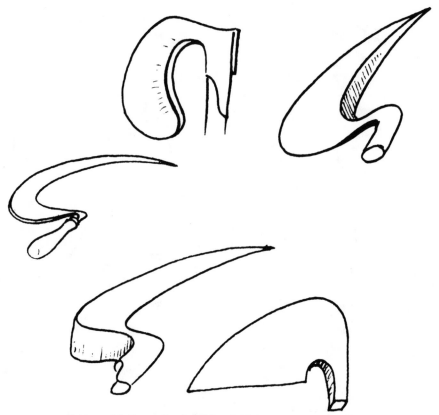

Falcate, falciform (Latin: *falx,* sickle)

Hamiform, hamulate (Latin: *hamus,* hook)
also Unciform, uncinate (Latin: *uncus,* claw)

Hastate (Latin: *hastatus,* arrow-shaped)
 also Halbert (Middle English: *halberd,* handle)
 Lanciform, lancinate (Latin: *lancinatus,* pierced)

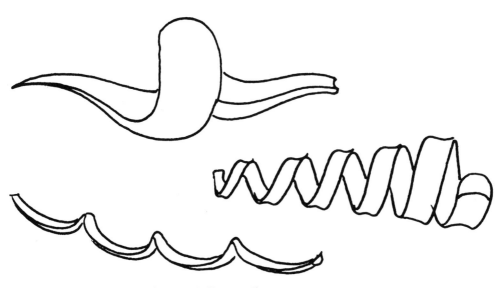

Helical, helicoid, helicoidal (Greek: *helix,* spiral)

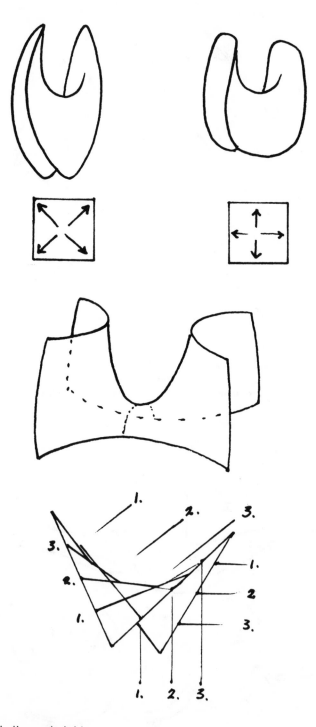

Hyperbolic paraboloid
also Anticlastic surface

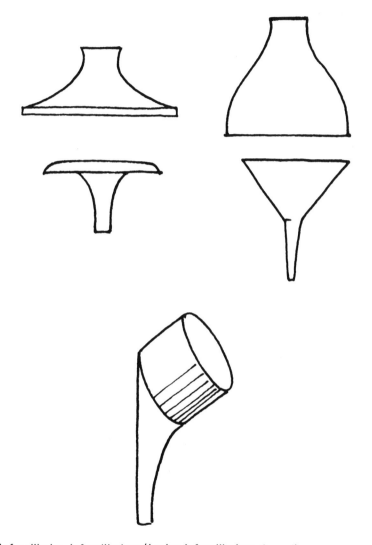

Infundibular, infundibulate (Latin: *infundibulum*, funnel)

Isogonal (Greek: *isogonia*, equiangular)

Isthmian, isthmus (Greek: *isthmos,* passage connecting two structures)

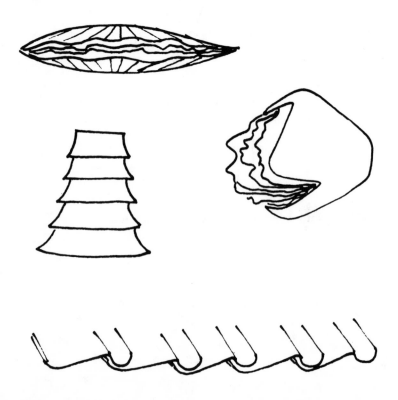

Lamellar, lamellate, lamelliform (Latin: *lamina,* plate)

Lenticular, lentiform (Latin: *lenticulatus,* lens-shaped)

1. Plano-convex

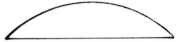

2. Bi-convex

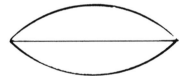

3. Bi-concave

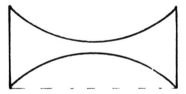

4. Concavo-convex

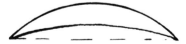

5. Plano-convex

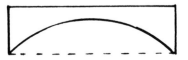

Menisciform, meniscoid, meniscoidal, meniscus (Greek: *meniskos,*
 also Crescent crescent)

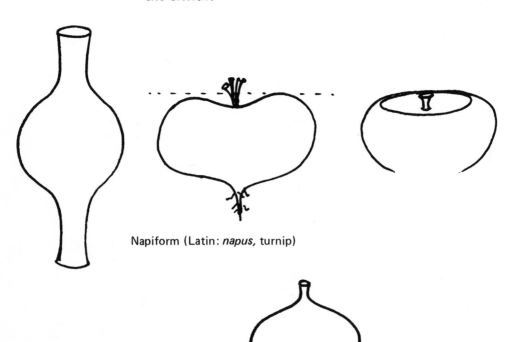

Napiform (Latin: *napus,* turnip)

also Corm (Latin: *cormus,* tree trunk)

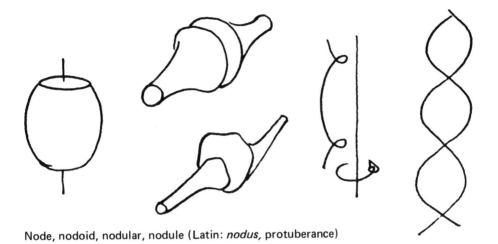

Node, nodoid, nodular, nodule (Latin: *nodus,* protuberance)

Oblique prism

Octahedron

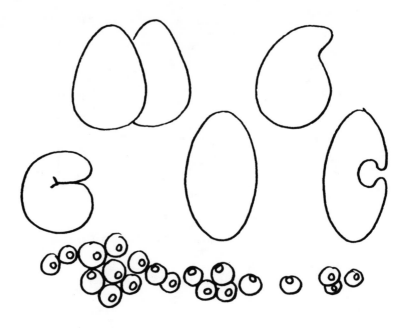

Oval, ovate, oviform, ovoid (Latin: *ovum,* egg)

Parallelopiped

132

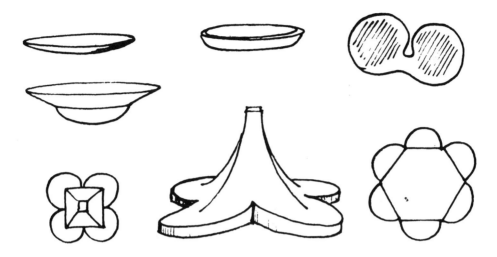

Paten (Middle English: small thin disc)
also Patella, patellate, patelliform (Latin: *patella,* small dish)

Pelta, peltate (Latin: *pelta,* small shield)
also Clypeate, clypeiform (Latin: *clypeus,* shield)
Scutate, scutiform (Latin: *scutum,* shield)

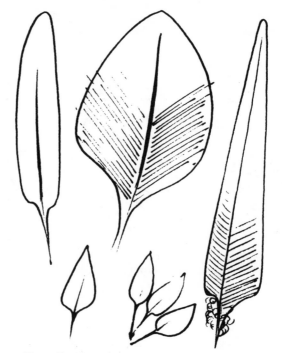

Pennate, penniform (Latin: *pennatus*, winged)

Phytomorphic (Greek: *phyton*, plant)

Prismatoid Pyramid

Pyriform (Latin: *pyriformis,* pear-shaped)

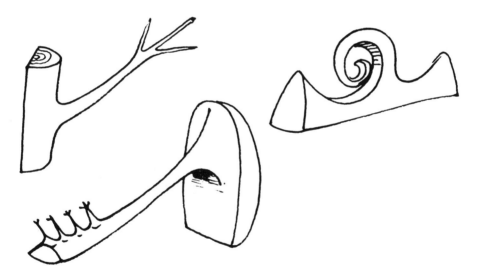

Ramose, ramous (Latin: *ramosis,* branchlike)

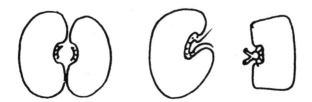

Reniform, renoid (Latin: *renes,* kidneys)

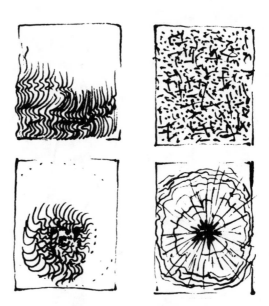

Reticular, reticulate, retiform (Latin: *reticulum,* net)
also Rugate, rugous (Latin: *rugatus,* wrinkled)

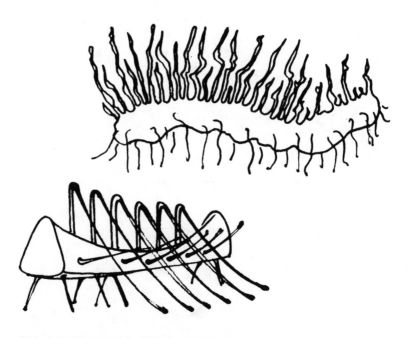

Rhizoid, rhizomorphic (Greek: *rhiza,* root)

Rimose, rimous (Latin: *rimosus,* crack, fissure)

Rostral (Latin: *rostrum,* beak)
also Rhamphoid (Greek: *rhamphos,* beak)

Runcinate, runcinoid (Latin: *runcinatus,* leaf-shaped, saw-edged)

Saccate (Latin: *saccus,* sac, pouch)

Sagittal, sagittate, sagittoid (Latin: *sagitta,* arrow)

Scalar, scalariform (Latin: *scala,* ladder)

Serpentine, serpentiform (Latin: *serpentinus,* serpent)
also Lumbriciform (Latin: *lumbrus,* worm)
Vermiform (Latin: *vermis,* worm)

Setaceous, setiform (Latin: *seta,* bristle)

Sigmoid (Greek: *sigma,* Greek letter Σ)
also Ogee

Sinus, sinusoid, sinusoidal line

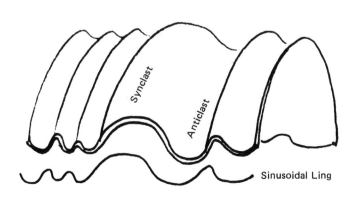

Synclast

Anticlast

Sinusoidal Ling

Spathe, also spadix (Greek: *spathe,* broadsword)

Spatula, spatulate (Latin: *spatula,* small spathe)

Sphene, sphenoid (Greek: *sphen,* wedge)

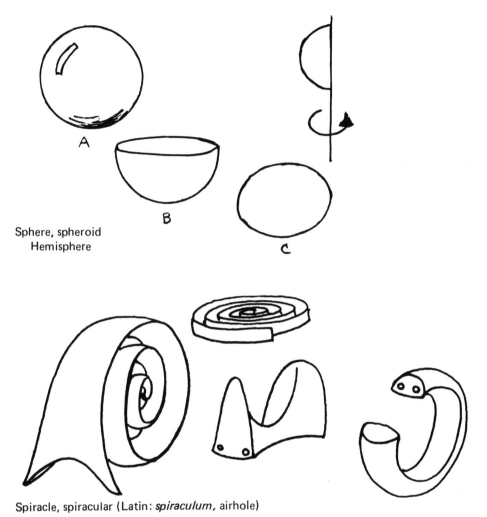

Sphere, spheroid
Hemisphere

Spiracle, spiracular (Latin: *spiraculum,* airhole)

Spiral, spiroid (on one plane 1/m compare with helix)

Stellar, stellate, stelliform (Latin: *stella,* star)

Strigal, strigous (Latin: *strigosus,* grooved)

Tendon, tendril, tendroid

Tetrahedron

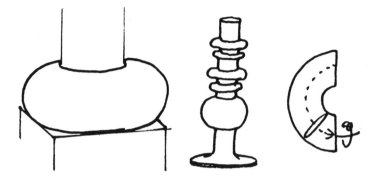

Torus, toroid (Latin: *torus,* cushion)

Triangular right prism

Trihedral and dihedral angles

Tubular, tubate
 also Fistulous (Latin: *fistulosus,* pipe-shaped)

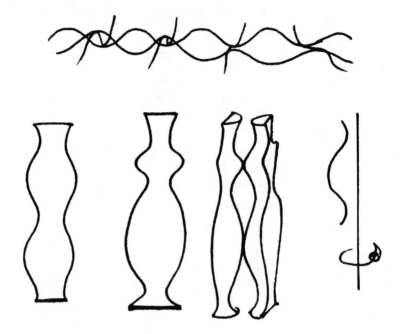

Undulatory (Latin: *undulatus,* wavy)

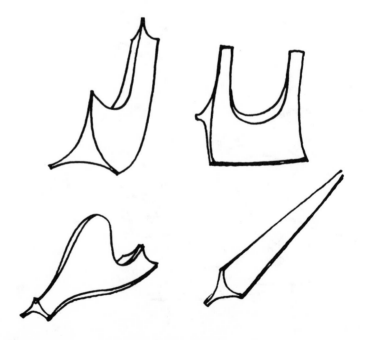

Xiphoid (Latin: *xiphoides,* sword-shaped)

Zoomorphic (Greek: *zoon,* animal)
 Bovine (Latin: *bovinus,* ox, cow)
 Canine (Latin: *canis,* dog)
 Corvine (Latin: *corvinus,* crow)
 Equine (Latin: *equus,* horse)
 Feline (Latin: *felinus,* cat)
 Molluscoid (Latin: *mollusca,* shellfish)
 Ornithoid (Greek: *ornithos,* bird)
 Pachydermous (Greek: *pachydermos,* hoofed animal)
 Piscine (Latin: *piscis,* fish)
 Reptilian (Latin: *reptilia,* reptile)
 Serpentine (Latin: *serpentinus,* serpent)
 Ursine (Latin: *ursinus,* bear)
 Vulpine (Latin: *vulpinus,* fox)

TERMS USED IN STUDY OF CIRCLES

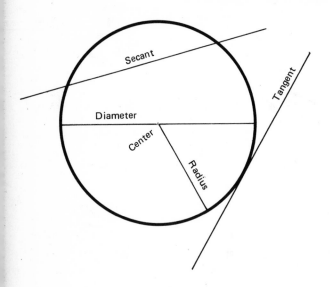

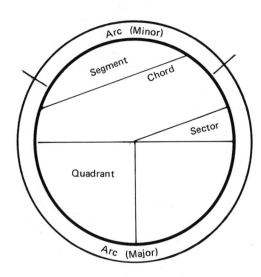

Concentric Circles

Inscribed Angles